150

Masterpieces of Drawing

Selected by Anthony Toney

Dover Publications, Inc., New York

Published in Canada by General Publishing Company, Ltd., 30 Lesmill Road, Don
Mills, Toronto, Ontario.
Published in the United Kingdom by Constable and Company, Ltd.

150 Masterpieces of Drawing is a new work, first published by Dover Publications, Inc.,
in 1963.

Standard Book Number: 486-21032-4
Library of Congress Catalog Card Number: 63–5656

Manufactured in the United States of America
Dover Publications, Inc., 180 Varick Street, New York, N. Y. 10014

LIST OF PLATES

*All measurements are given in inches, with the width given before the height.

31 WOLF HUBER (German, 1480–1549).

Portrait of a young woman. Dated 1544. Red chalk drawing with background wash. $7\frac{1}{4} \times 9\frac{5}{16}$.

32 JÖRG BREU THE ELDER (German, ca. 1480–1537).

Honorific portrayal of Albert II, Frederick III, Maximilian I, and Charles V, flanked by spiritual and temporal dignitaries; the coat of arms, front center, is that of Charles V. Pen drawing with colored wash. $13\frac{1}{16} \times 10\frac{1}{2}$.

33 ALBRECHT ALTDORFER (German, 1480?–1538).

The sacrifice of Isaac in a fantastic landscape. Ink on olive green tinted paper, heightened with white. Reproduced original size.

34 HANS BALDUNG, called GRIEN (German, 1480?–1545).

Group of witches. Dated 1514. Ink on brown tinted paper, heightened with white. $8\frac{1}{8} \times 11\frac{1}{4}$.

35 BALDUNG.

Head of Saturn. Dated 1516. Crayon. $10\frac{1}{8} \times 13\frac{1}{8}$.

36 RAFFAELE SANTI (RAPHAEL; Italian, 1483–1520).

Three studies of Mary beneath the cross for the painting, "Christ on the Cross with Four Saints," about 1502. Pen drawing in bistre. $8\frac{3}{8} \times 10\frac{3}{4}$.

37 RAPHAEL.

The Madonna with a pomegranate. About 1502. Crayon. $11\frac{5}{8} \times 16\frac{1}{4}$.

38 RAPHAEL.

Four studies for the Vienna "Madonna in Rural Surroundings," 1505–1506. Pen drawing in bistre. $14 \times 9\frac{1}{4}$.

39 RAPHAEL.

The Muse Euterpe. Study for the "Parnassus" fresco in the Vatican. About 1510. Pen drawing in bistre. $8\frac{9}{16} \times 9\frac{5}{8}$.

40 URS GRAF. (German, 1485–1529).

Execution ground with a beheading. Dated 1512. Ink. $9\frac{1}{2} \times 8\frac{5}{8}$.

41 MARCO BASAITI (Italian, 1490–ca. 1521).

Christ's departure from the Apostles Peter, James, and John. Formerly attributed to Giovanni Bellini. Pen drawing on yellowed paper. $7\frac{5}{8} \times 10\frac{1}{8}$.

42 FRANÇOIS CLOUET (French, 1510–1572).

Portrait of a young man. Crayon, with face drawn in red chalk and rubbed. $8\frac{3}{4} \times 12\frac{3}{4}$.

43 PIETER BRUEGEL THE ELDER (Flemish, ca. 1520–1569).

Artist and Connoisseur. Pen drawing on white paper. $8\frac{5}{8} \times 10\frac{1}{4}$.

LIST OF PLATES

LIST OF PLATES

150

Masterpieces of Drawing

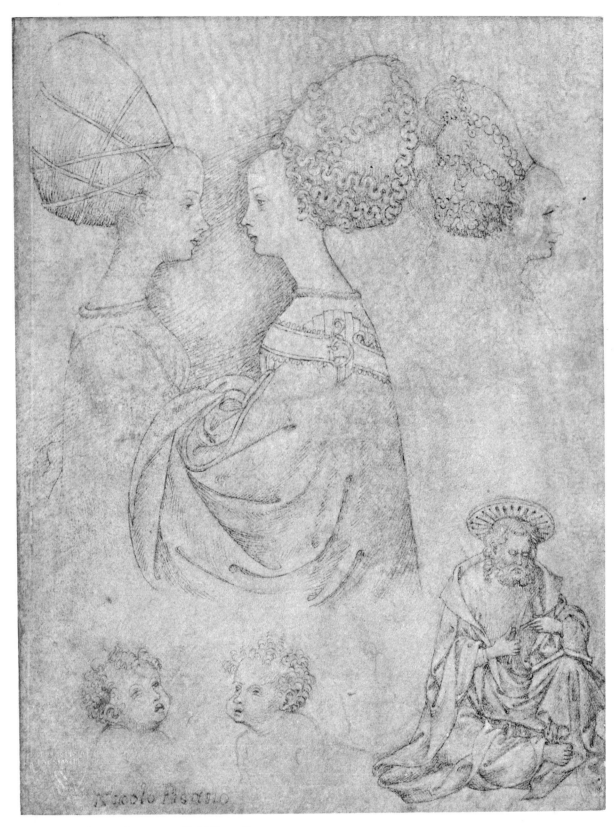

Plate 1. *Vittore Pisano, called Pisanello*

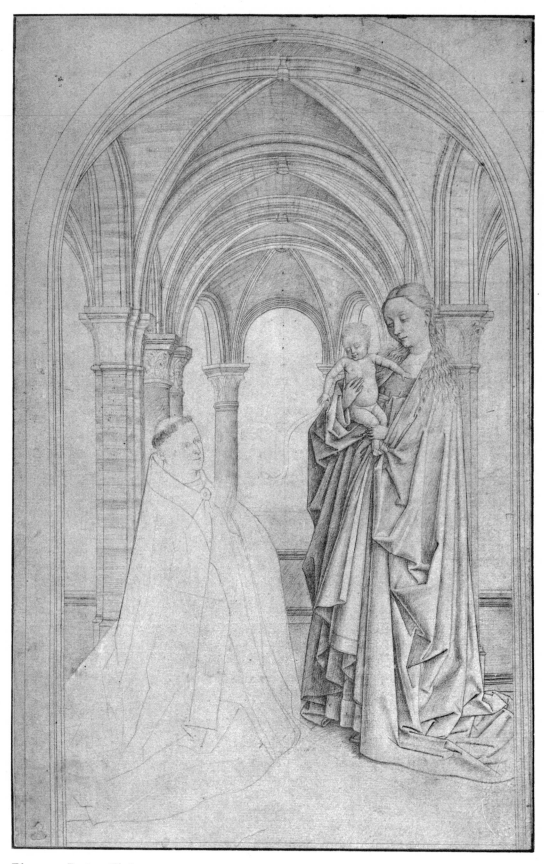

Plate 2. *Petrus Christus*

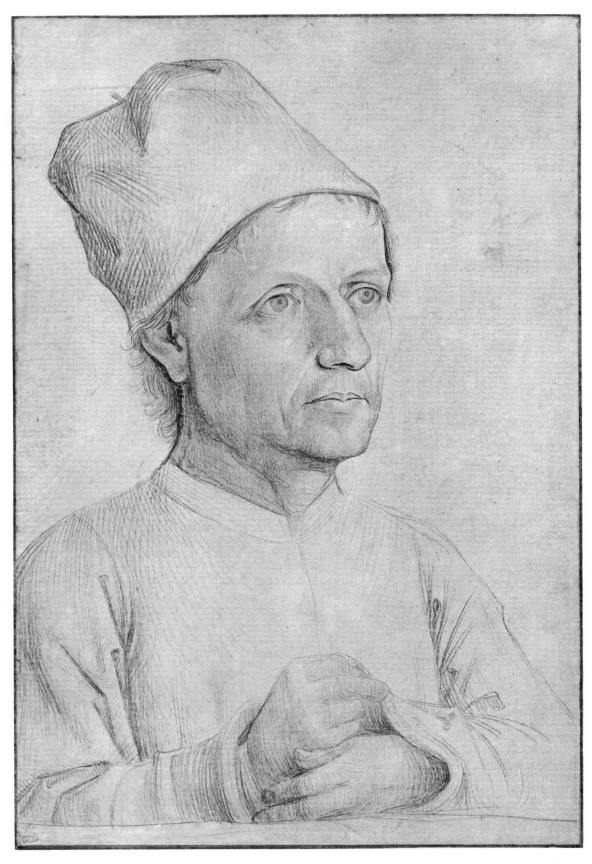

Plate 3. *Unknown Flemish master of the 15th century*

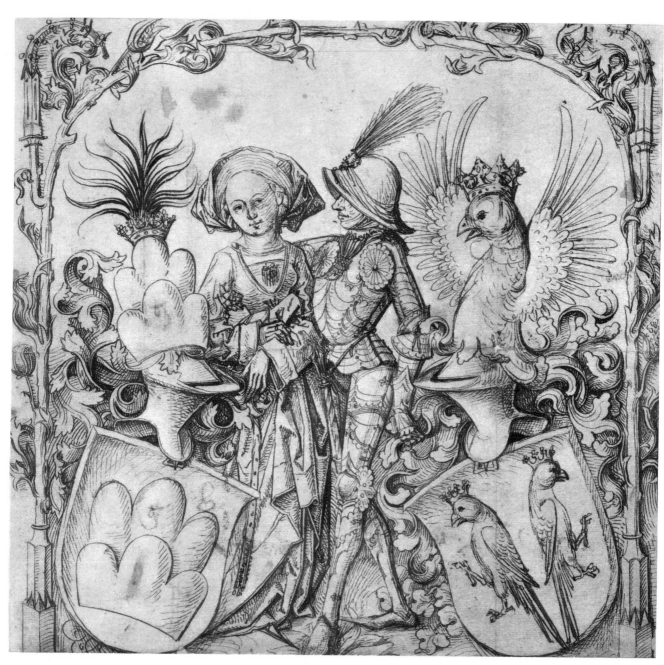

Plate 4. *Master of the Hausbuch*

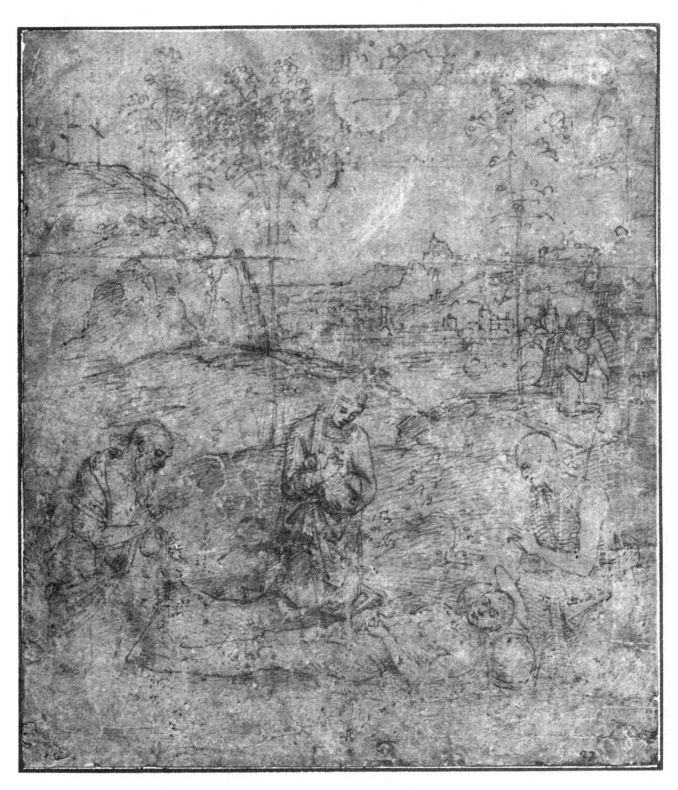

Plate 5. *Pietro Perugino*

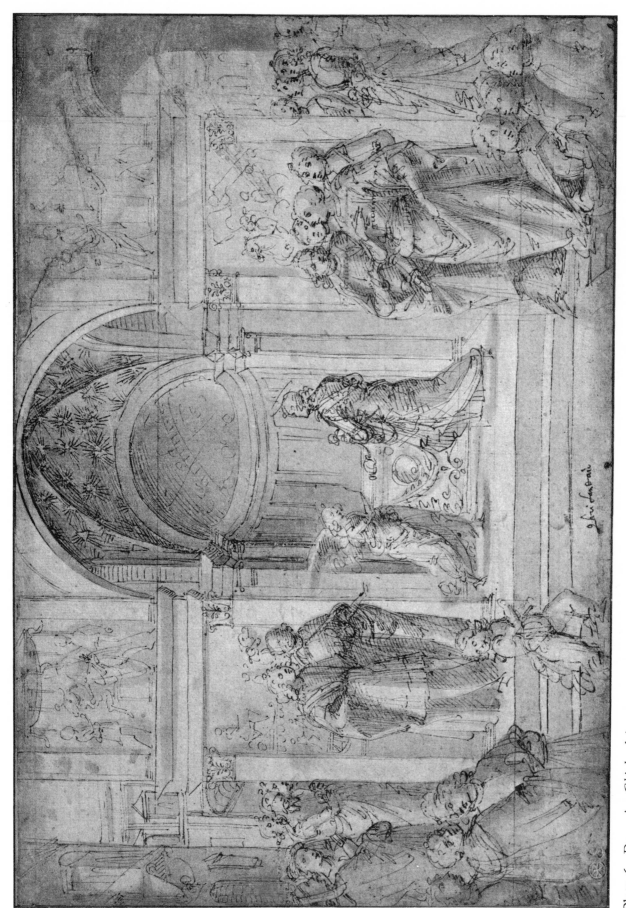

Plate 6. *Domenico Ghirlandaio*

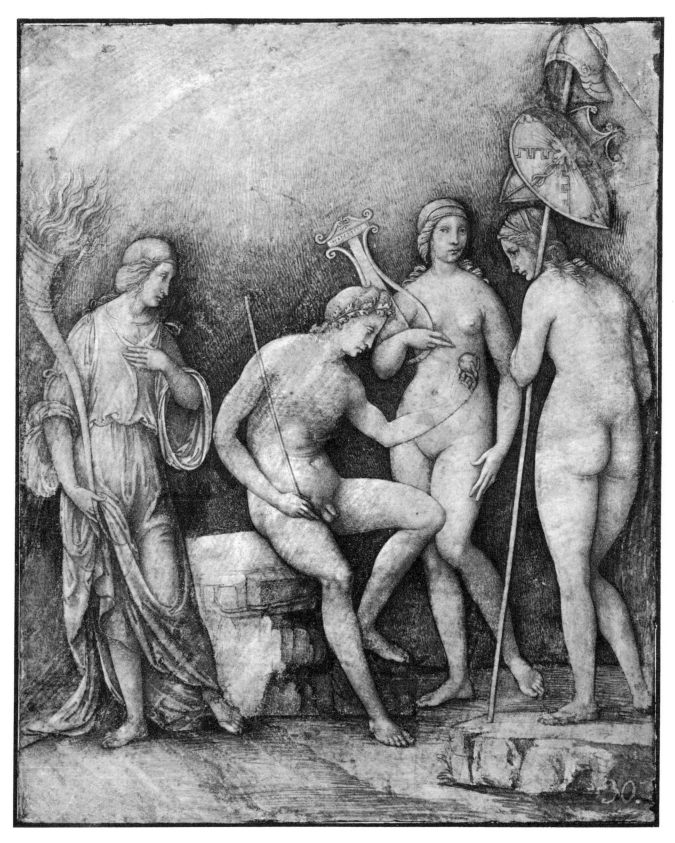

Plate 7. *Francesco Francia*

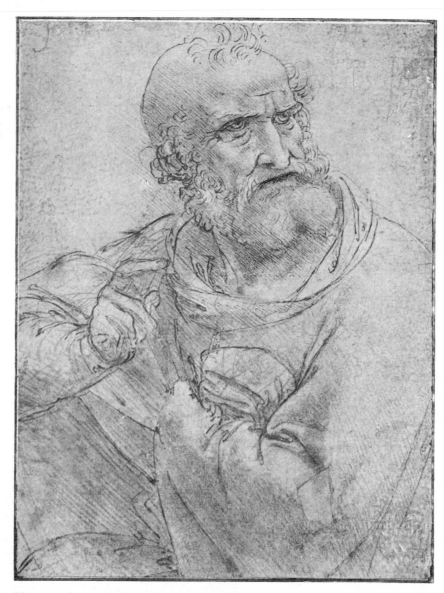

Plate 8. *Leonardo da Vinci*

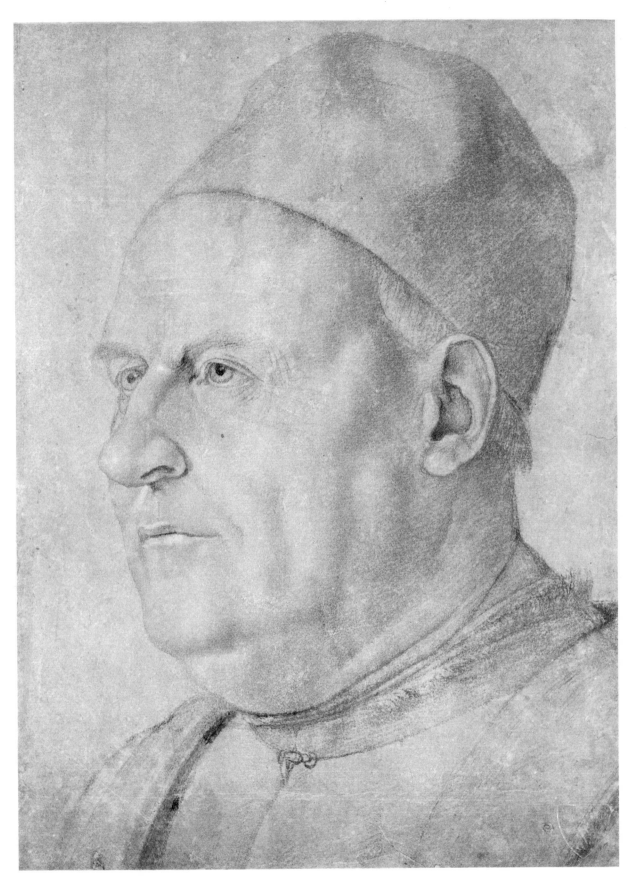

Plate 9. *Francesco Bonsignori*

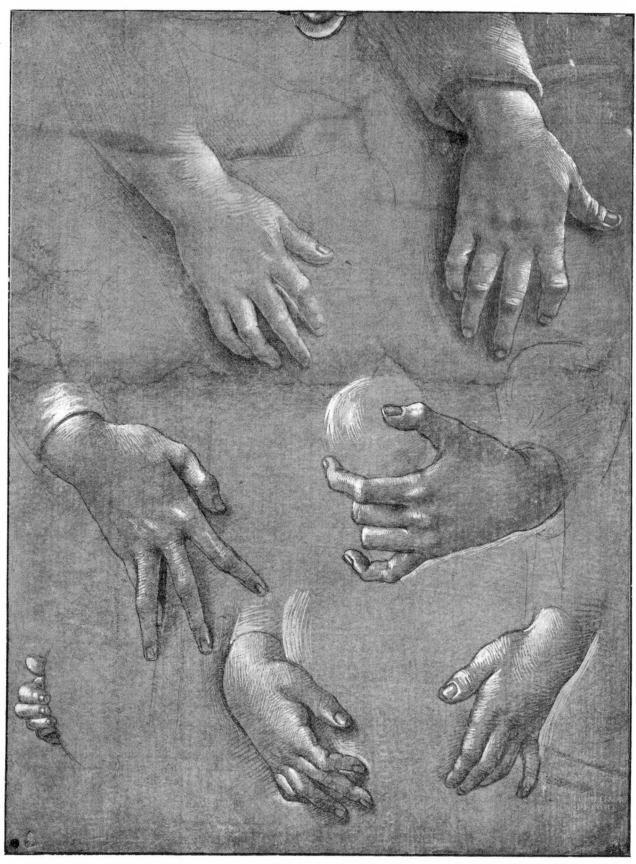

Plate 10. *Raffaellino del Garbo*

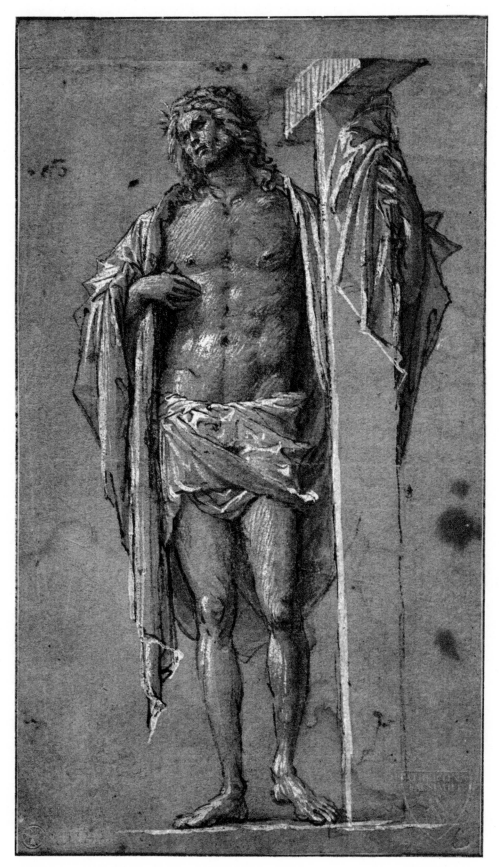

Plate 11. *Bartolommeo Suardi, called Bramantino*

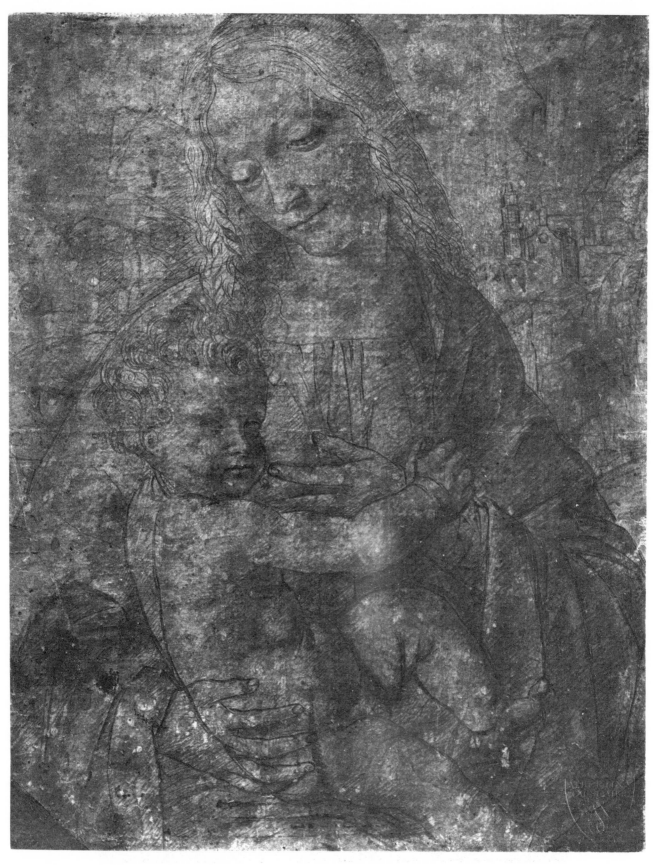

Plate 12. *Marco d'Oggiono*

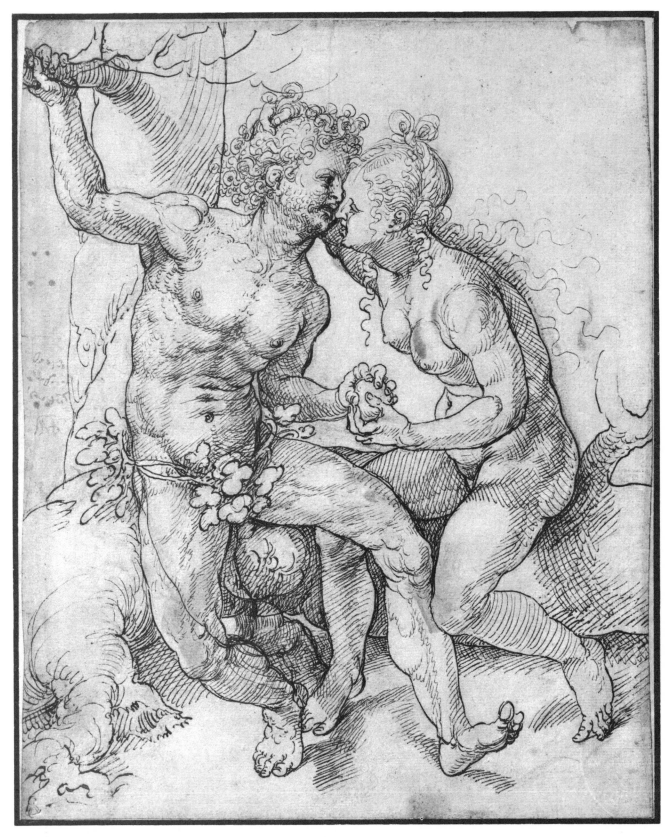

Plate 13. *Jan Gossaert Mabuse*

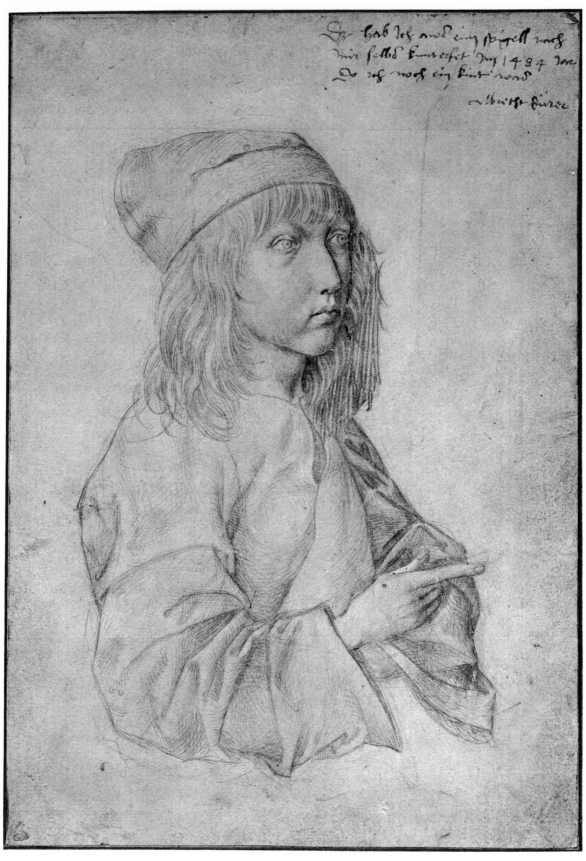

Plate 14. *Albrecht Dürer*

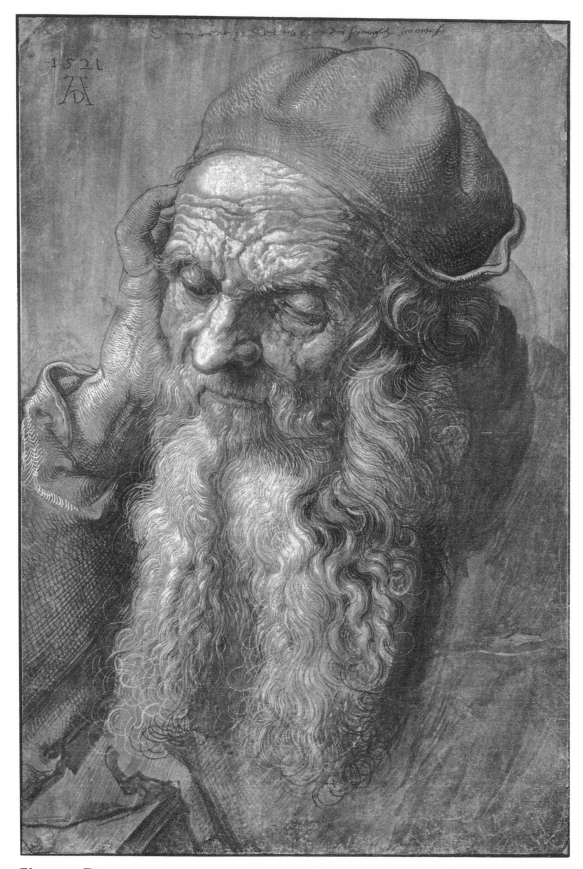

Plate 15. *Dürer*

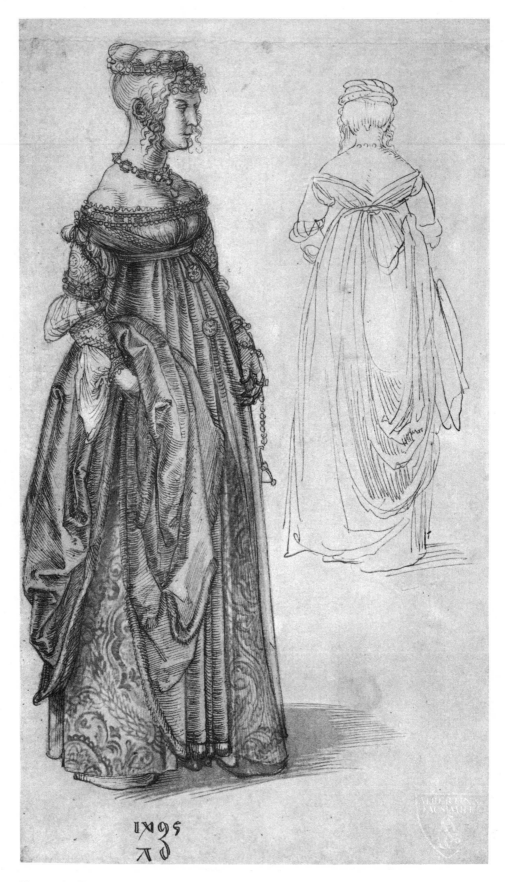

Plate 16. *Dürer*

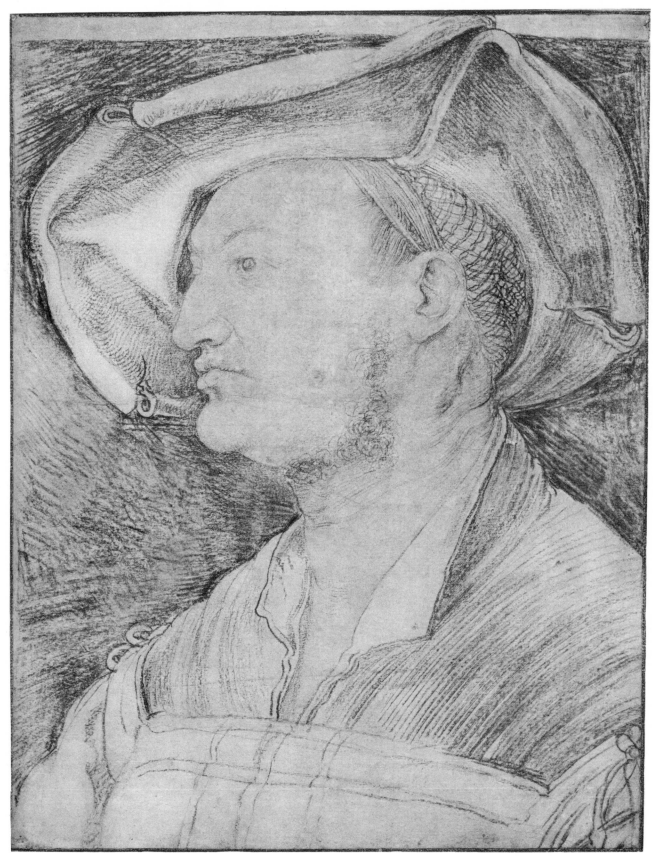

Plate 17. *Dürer*

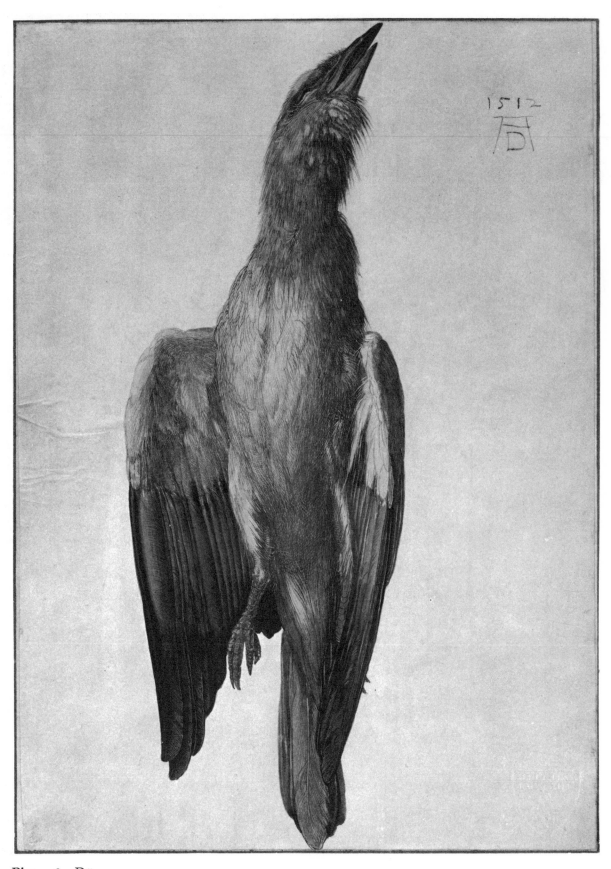

Plate 18. *Dürer*

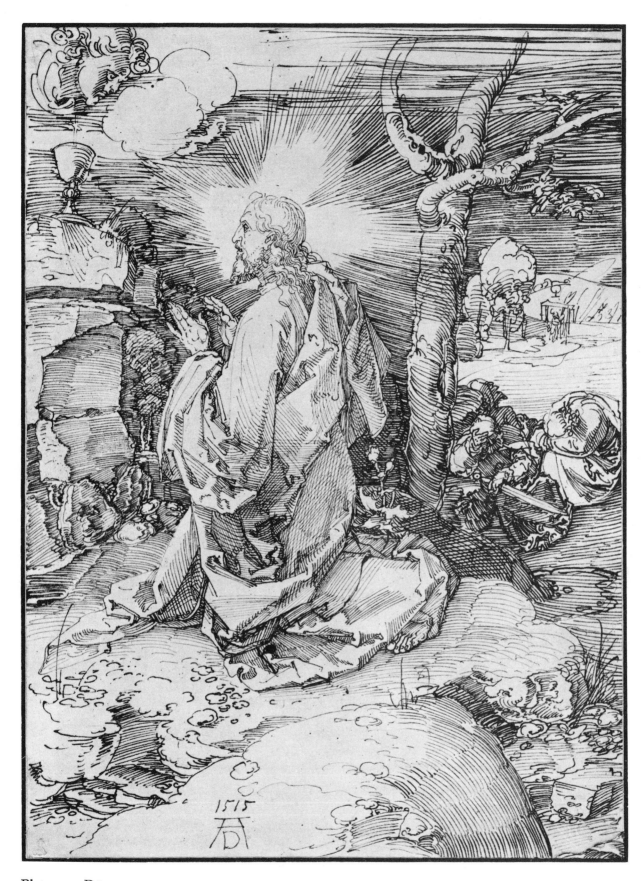

Plate 19. *Dürer*

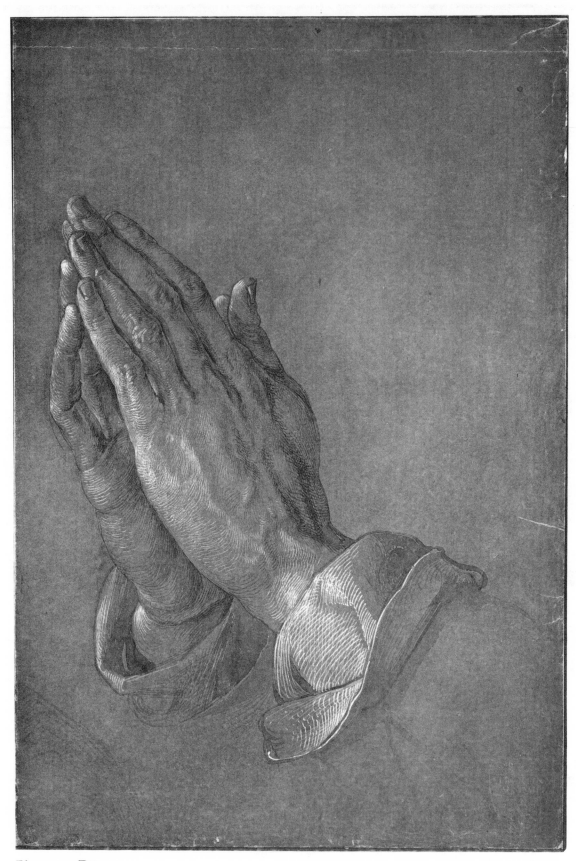

Plate 20. *Dürer*

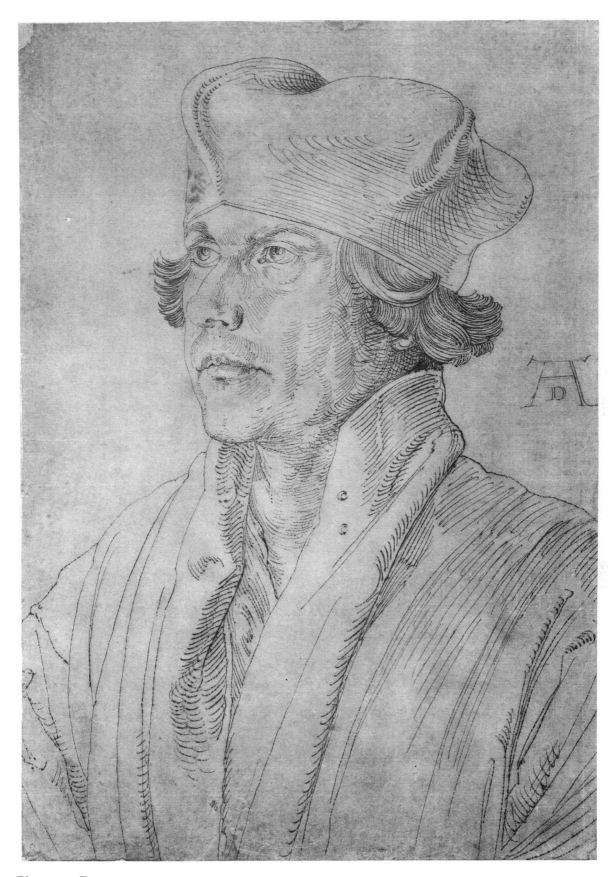

Plate 21. *Dürer*

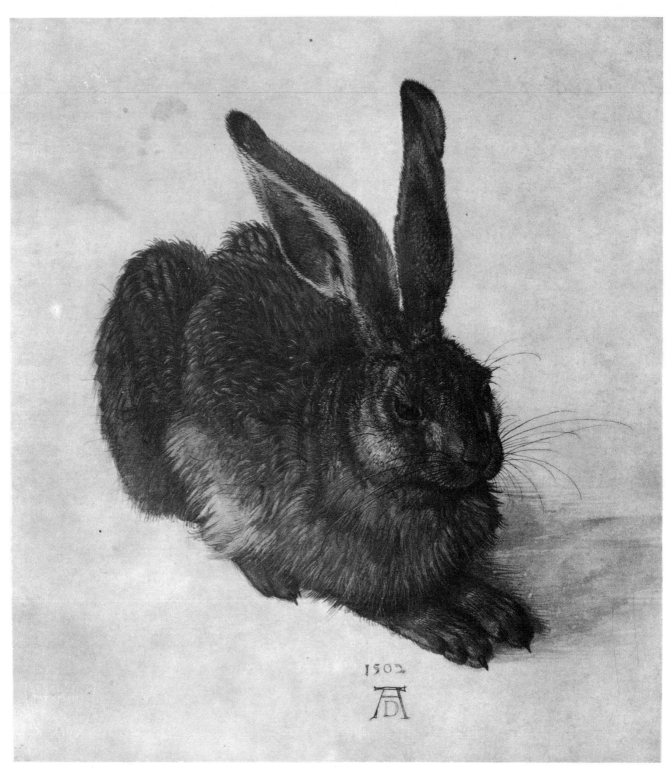

Plate 22. *Dürer*

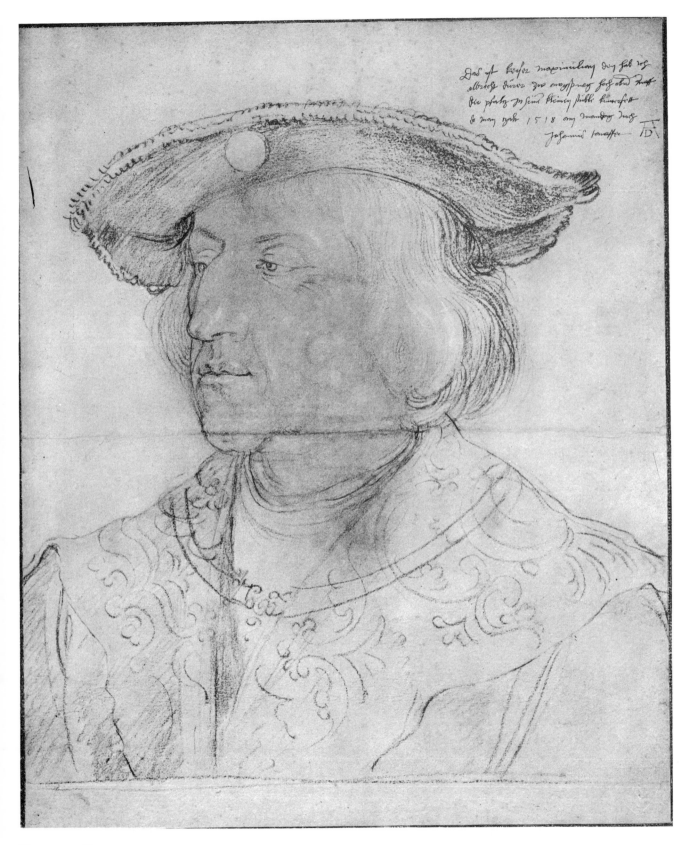

Plate 23. *Dürer*

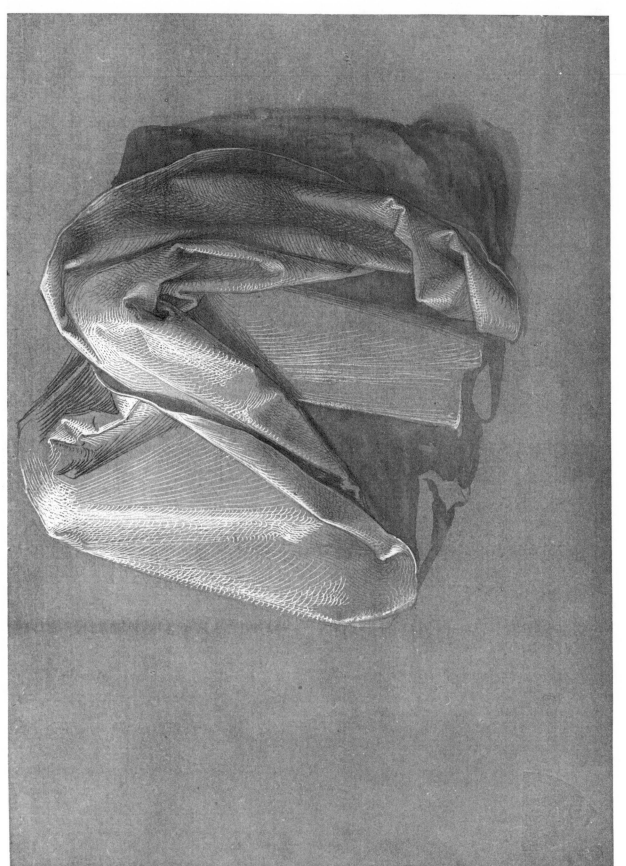

Plate 24. *Dürer*

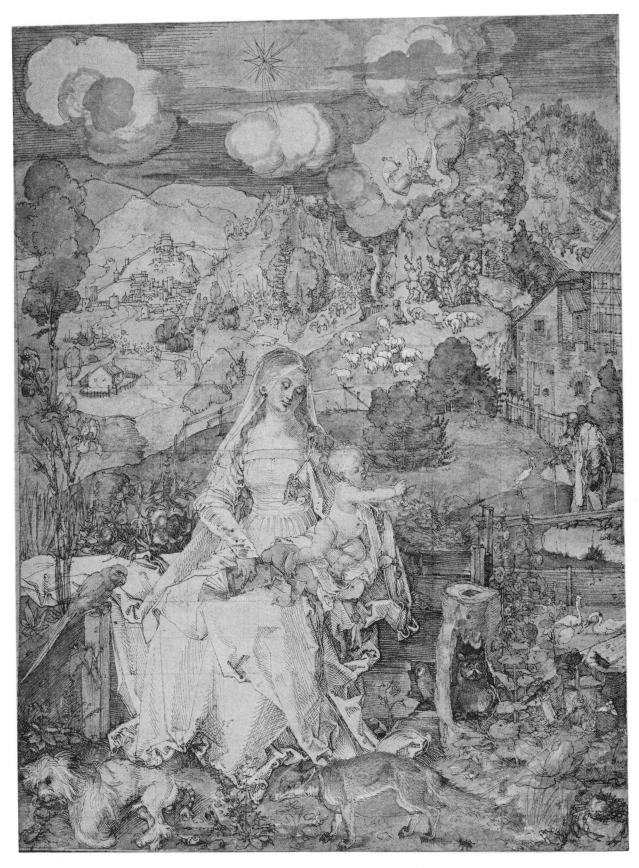

Plate 25. *Dürer*

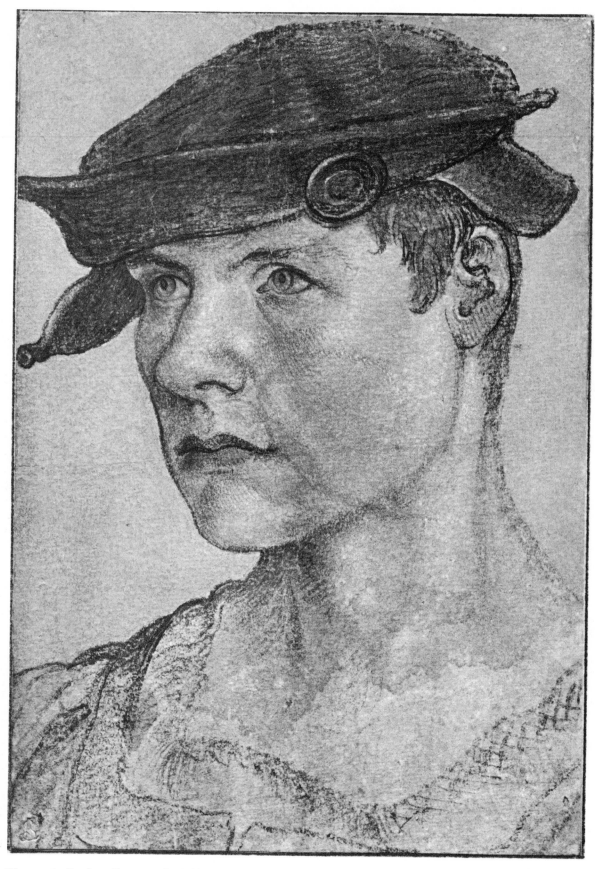

Plate 26. *Lukas Cranach the Elder*

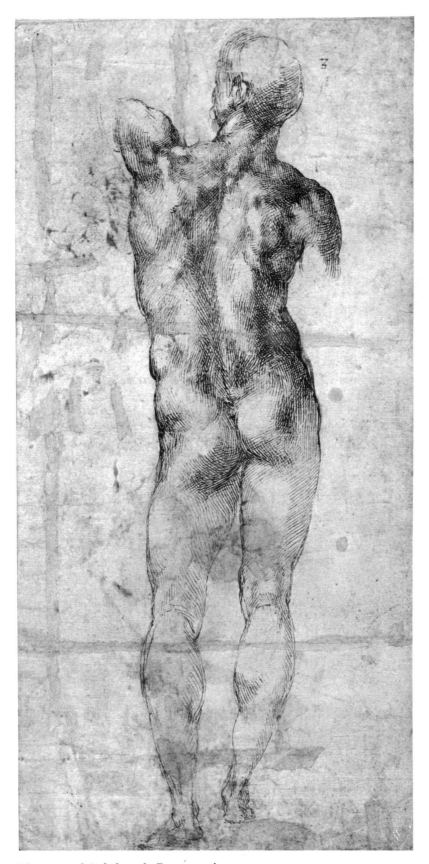

Plate 27. *Michelangelo Buonarroti*

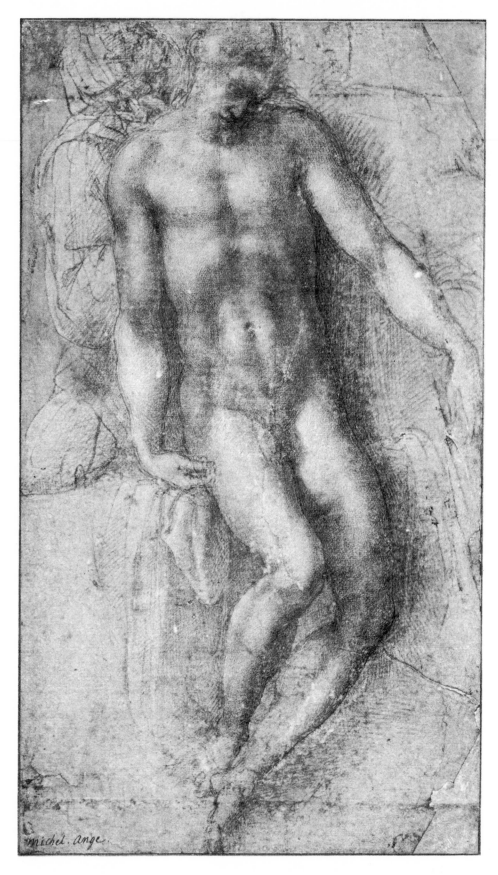

Plate 28. *Michelangelo*

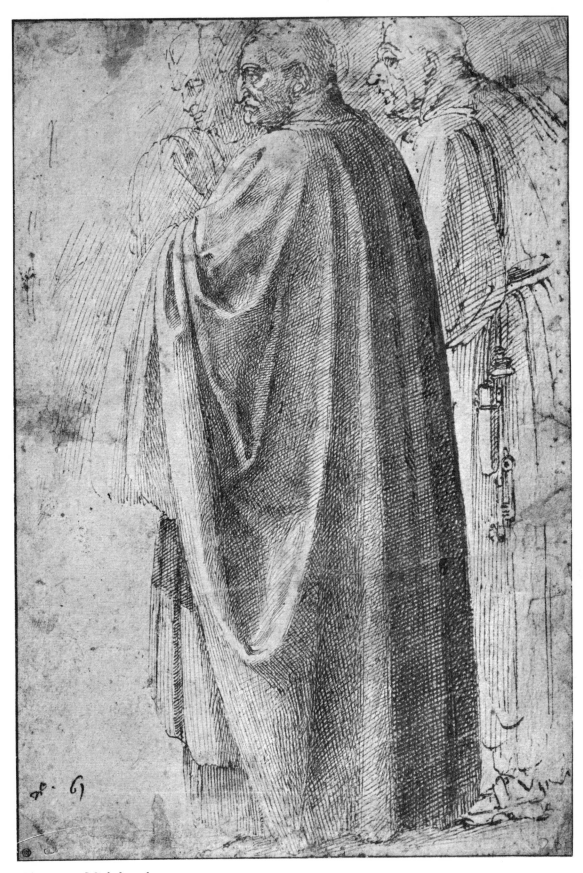

Plate 29. *Michelangelo*

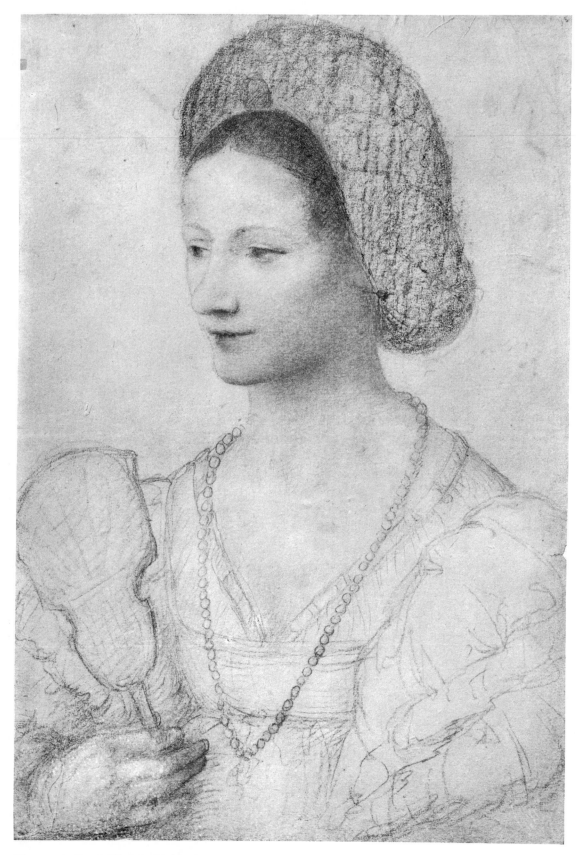

Plate 30. *Bernardino Luini*

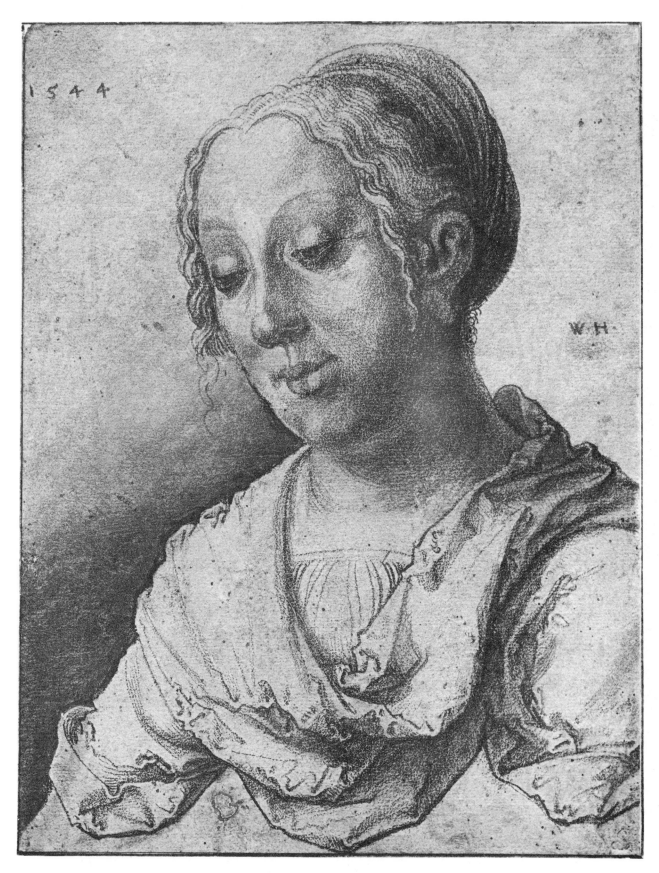

Plate 31. *Wolf Huber*

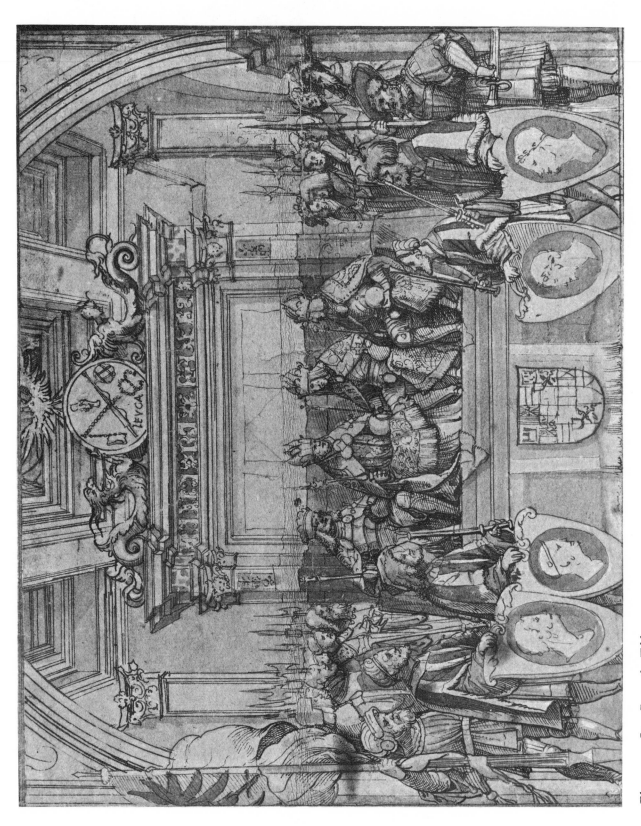

Plate 32. *Jörg Breu the Elder*

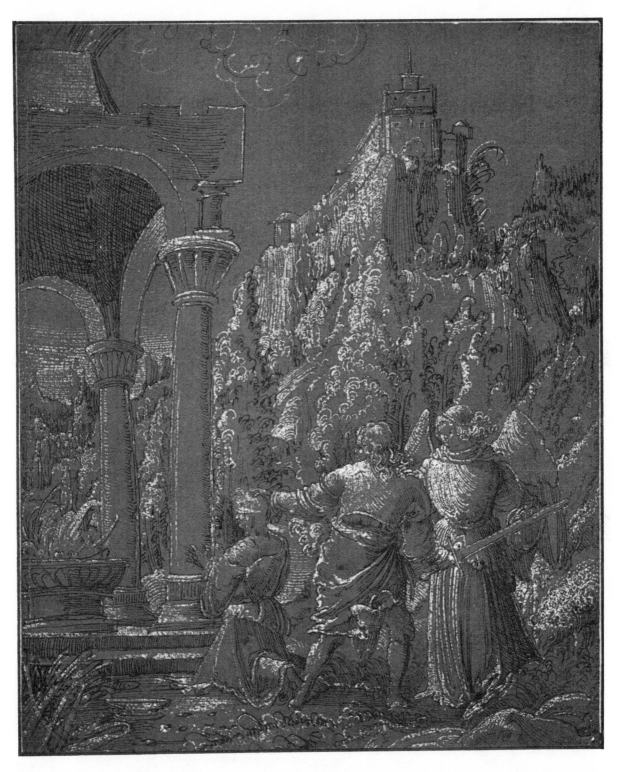

Plate 33. *Albrecht Altdorfer*

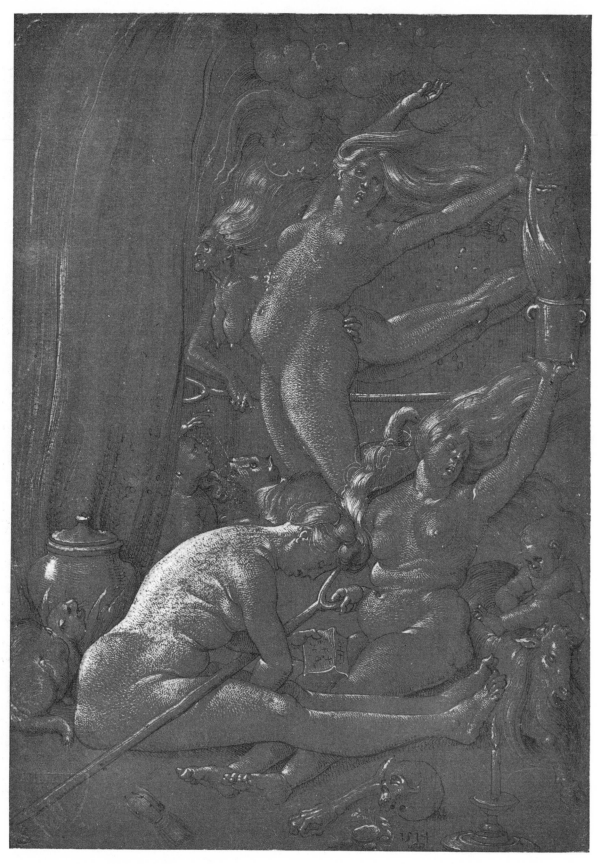

Plate 34. *Hans Baldung, called Grien*

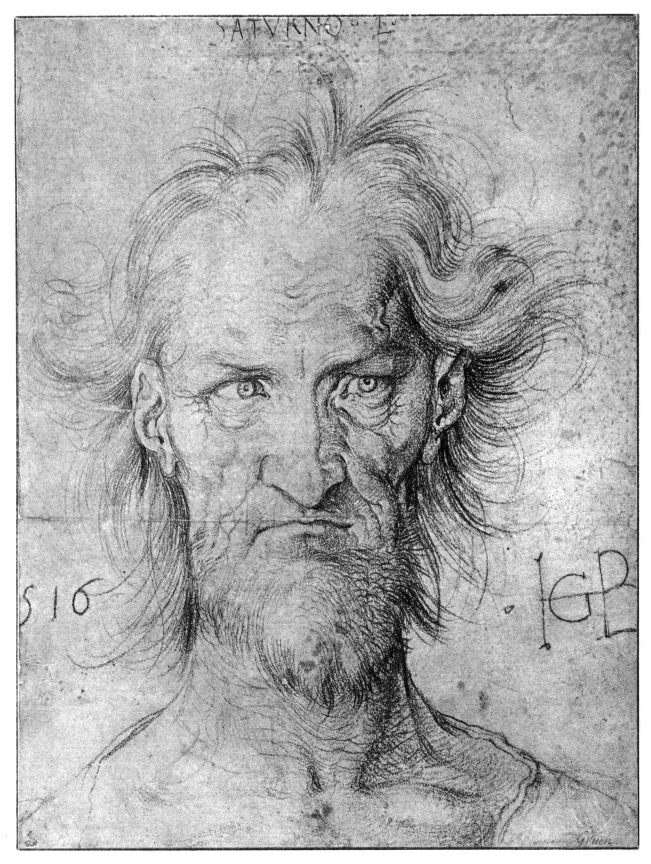

Plate 35. *Baldung*

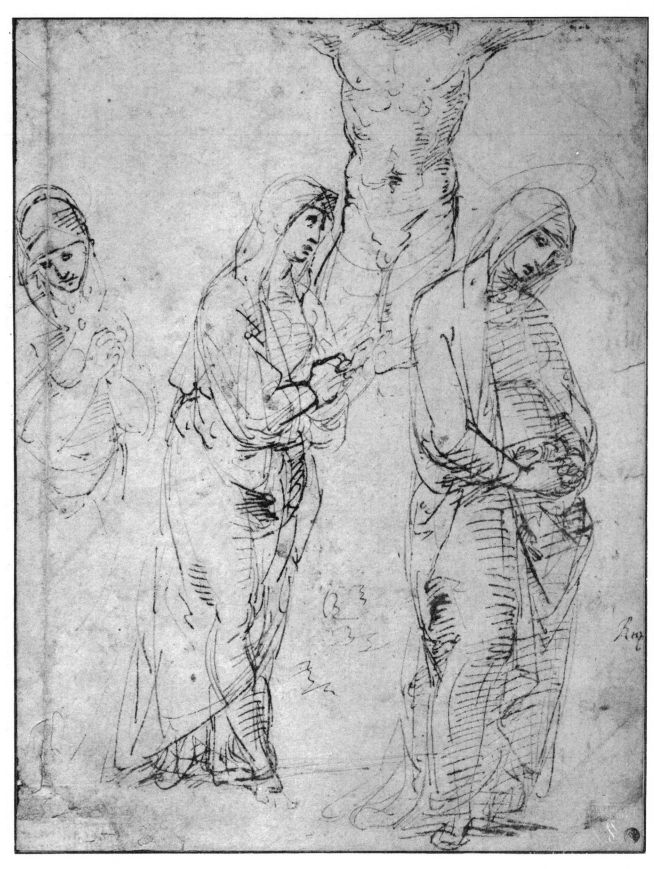

Plate 36. *Raffaele Santi* (*Raphael*)

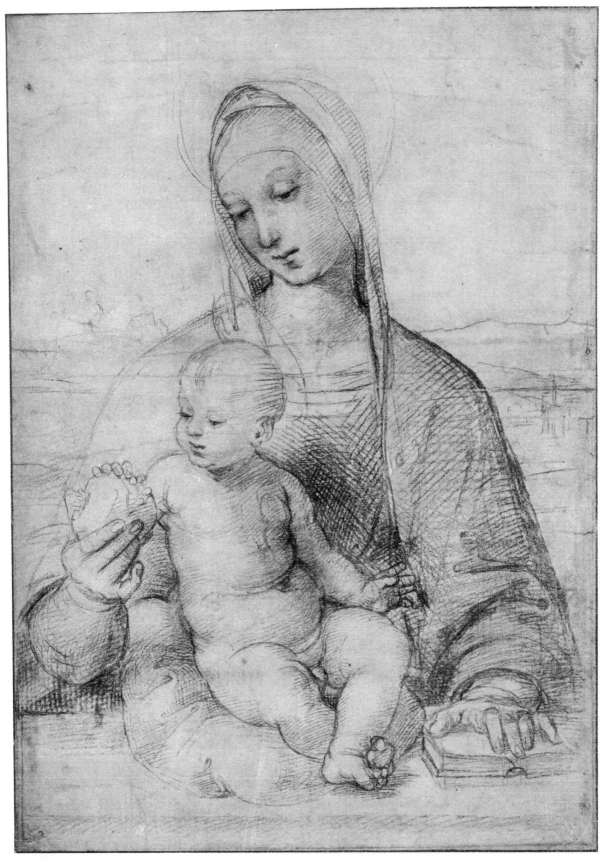

Plate 37. *Raphael*

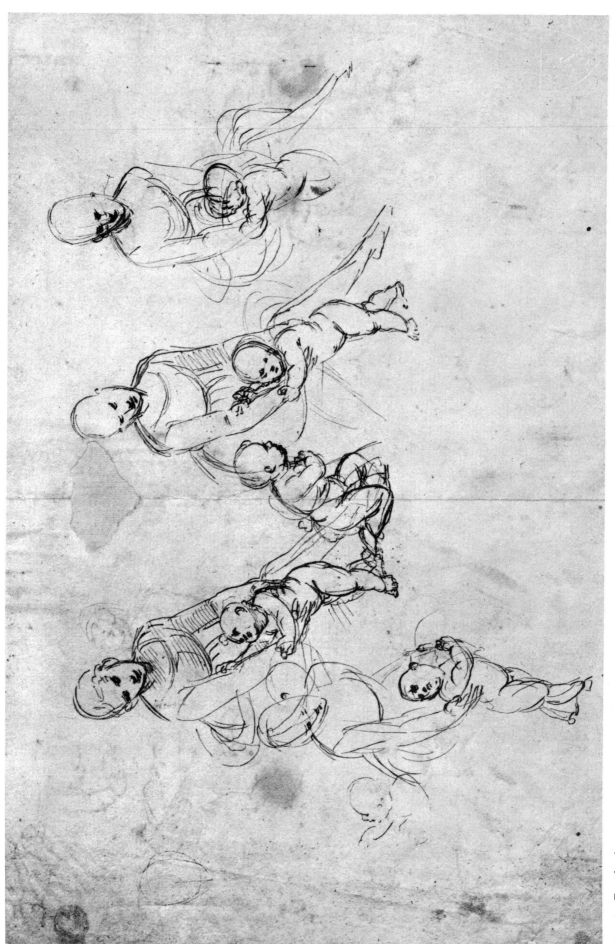

Plate 38. *Raphael*

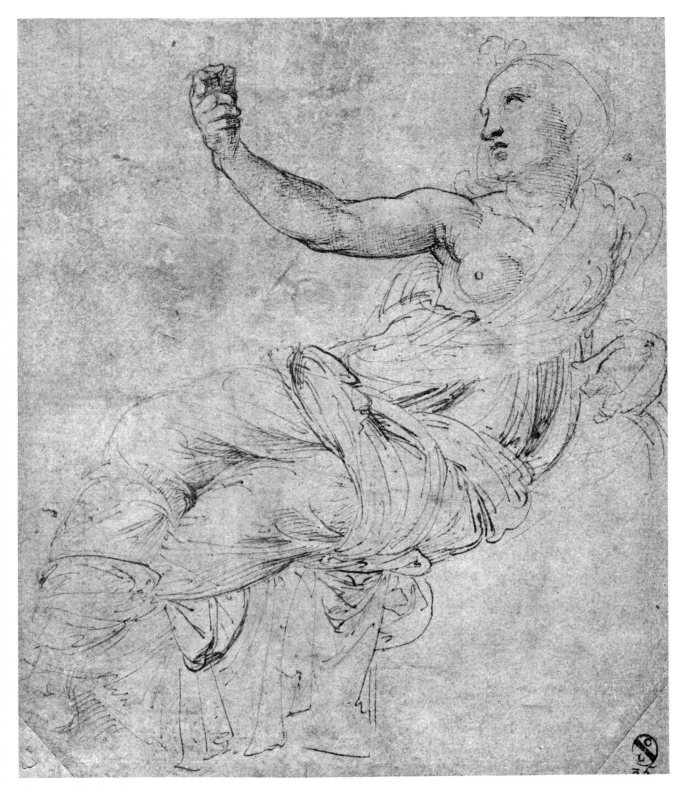

Plate 39. *Raphael*

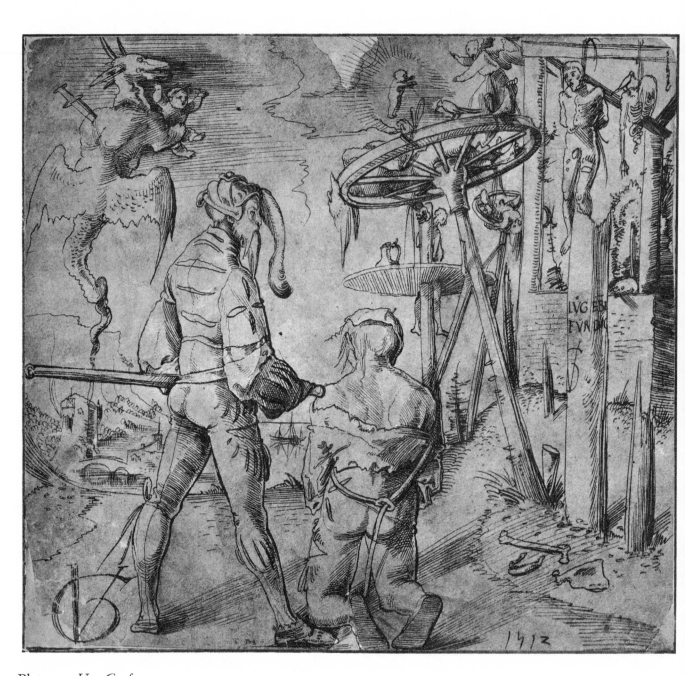

Plate 40. *Urs Graf*

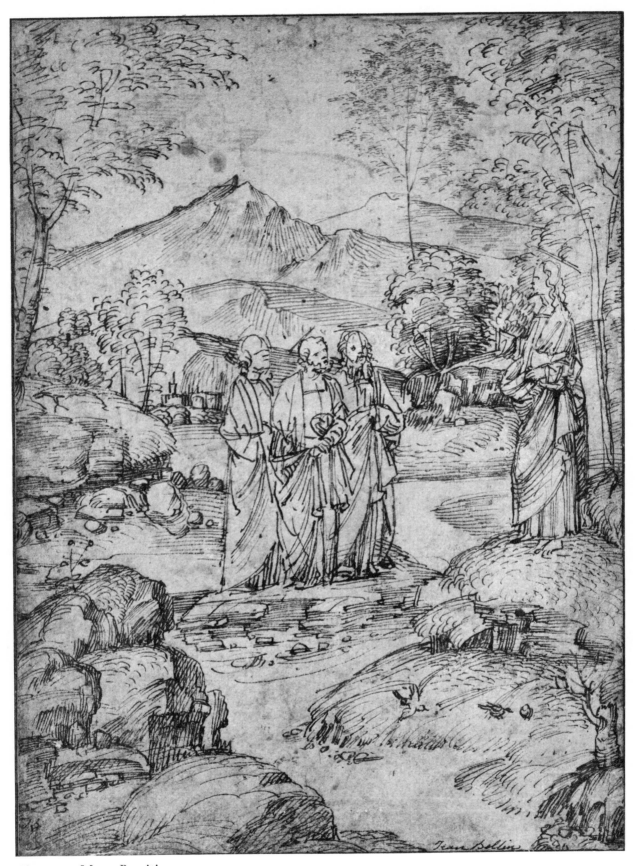

Plate 41. *Marco Basaiti*

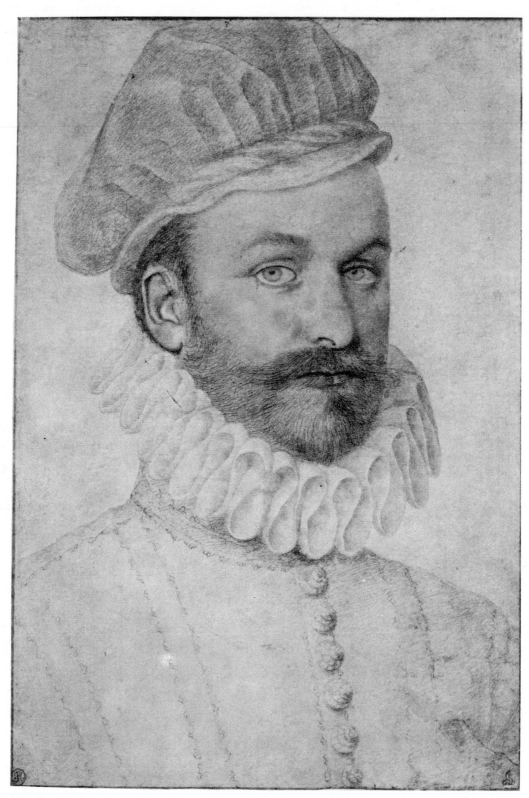

Plate 42. *François Clouet*

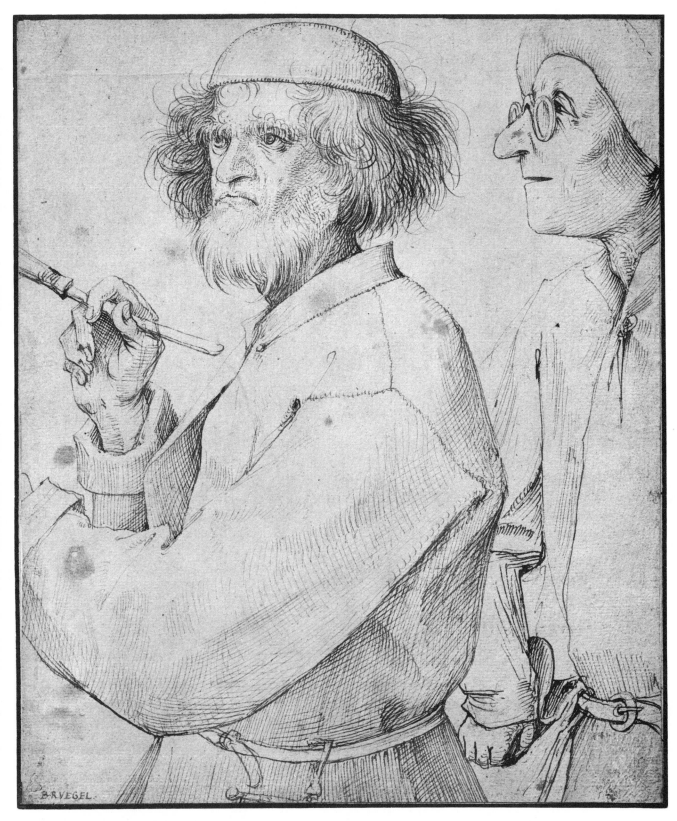

Plate 43. *Pieter Bruegel the Elder*

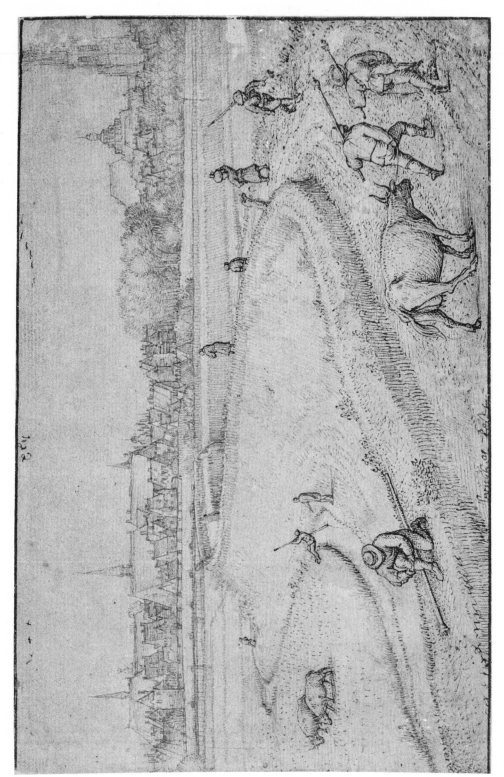

Plate 44. *Bruegel*

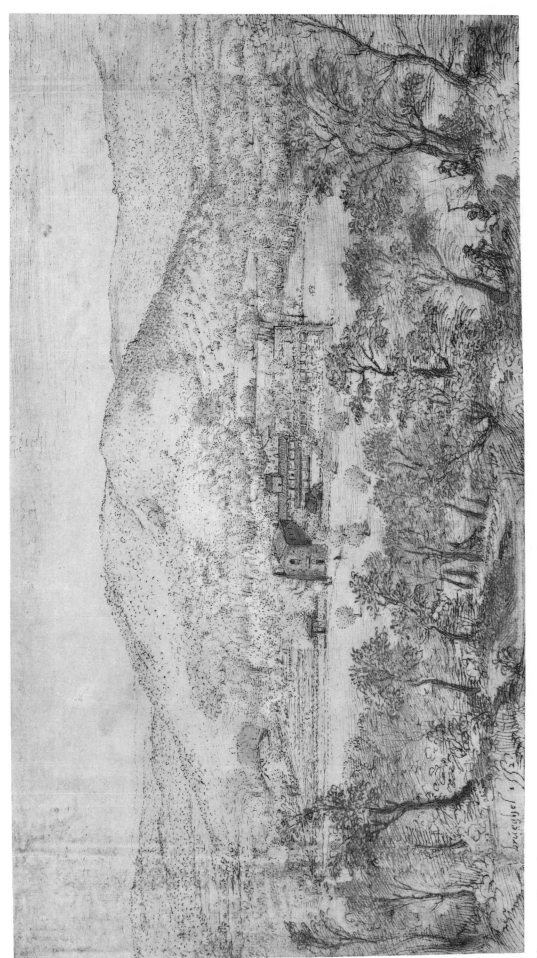

Plate 45. *Bruegel*

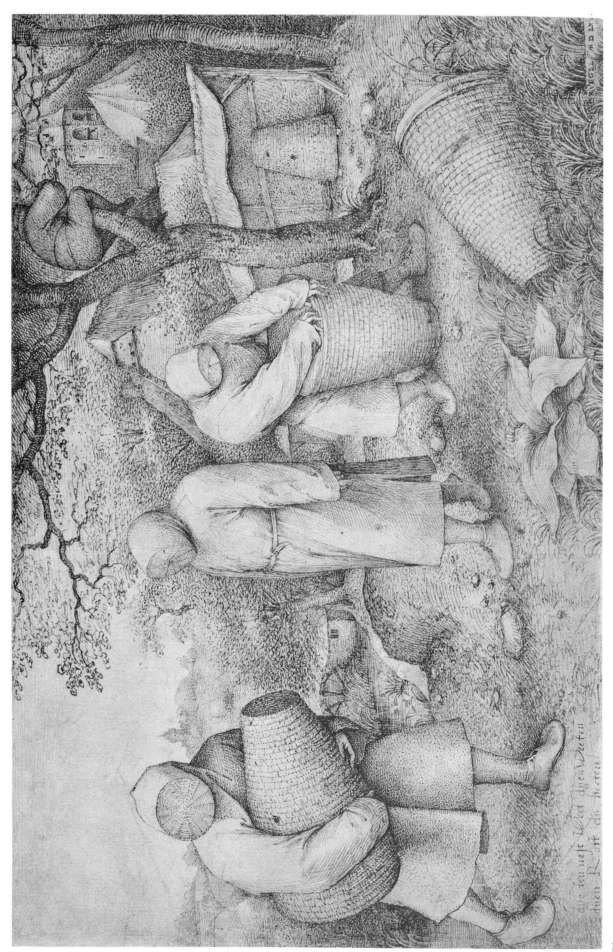

Plate 46. *Bruegel*

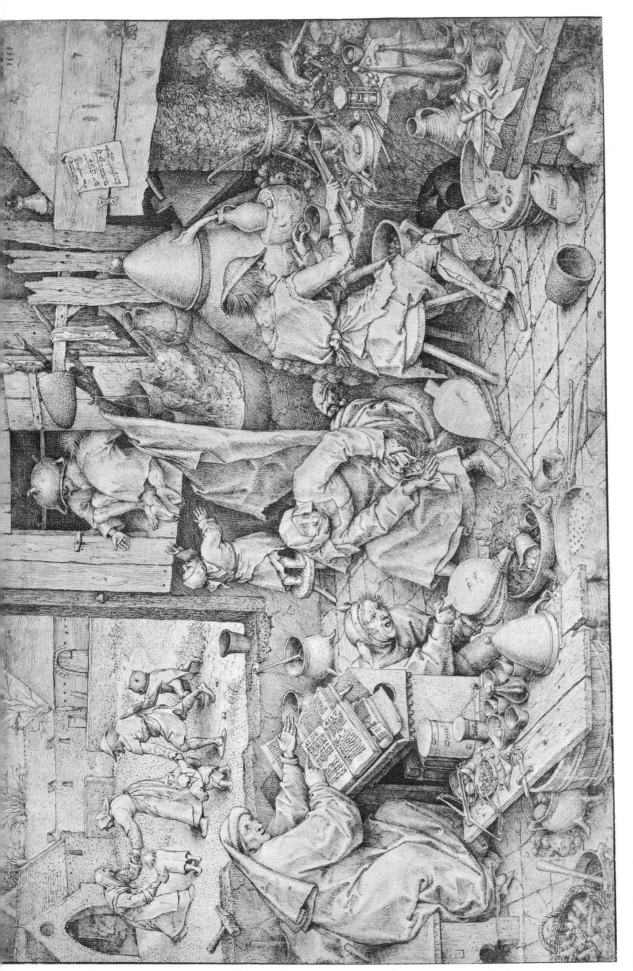

Plate 47. *Bruegel*

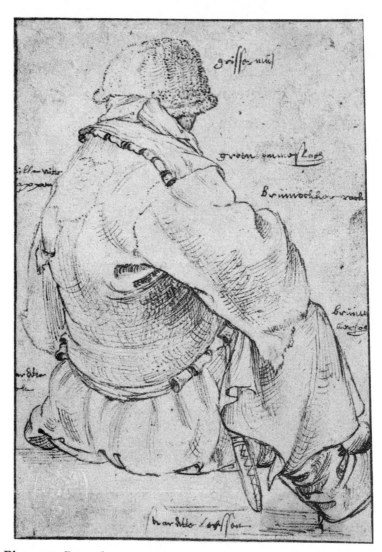

Plate 48. *Bruegel*

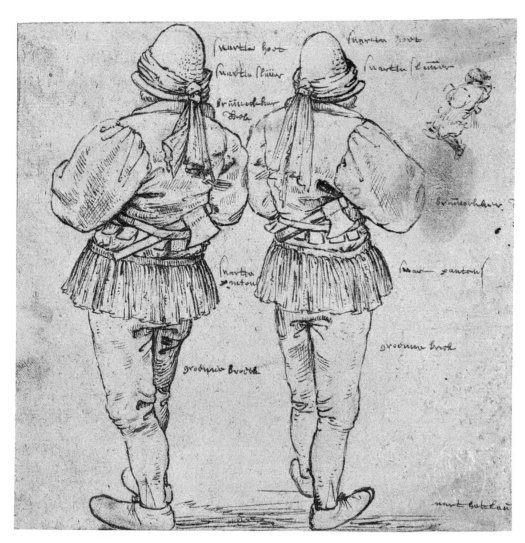

Plate 49. *Bruegel*

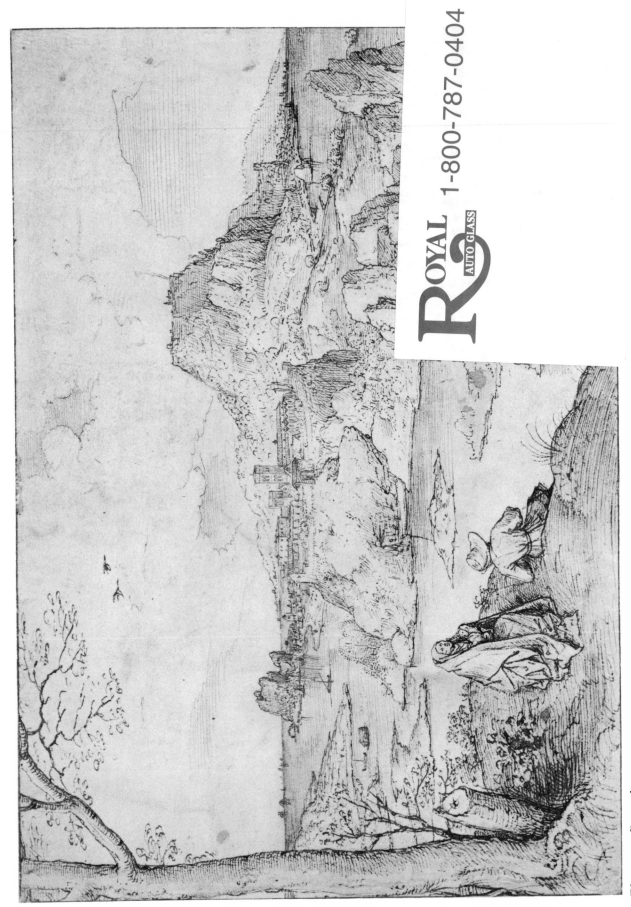

Plate 50. *Bruegel*

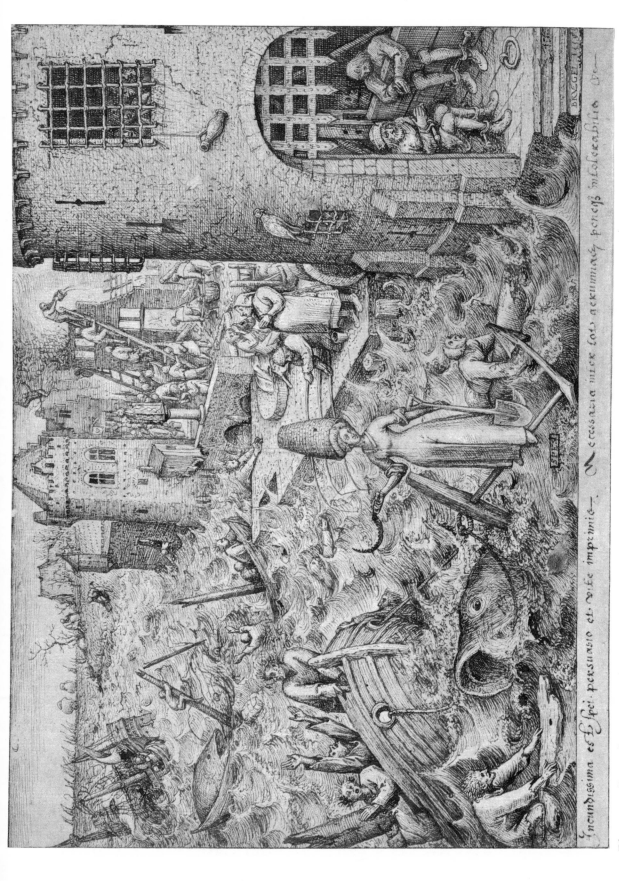

Iucundissima est Luci persuasio et acusibilis imprimis. Necessaria mox fort acumen potuiss insolorabilis gr.

Plate 51. *Bruegel*

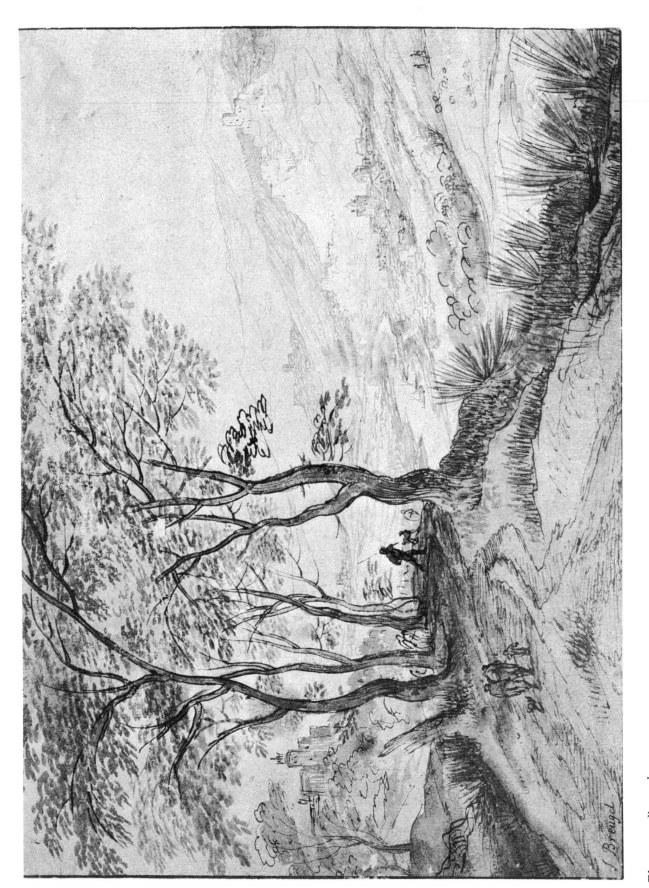

J. Breugel

Plate 52. Bruegel

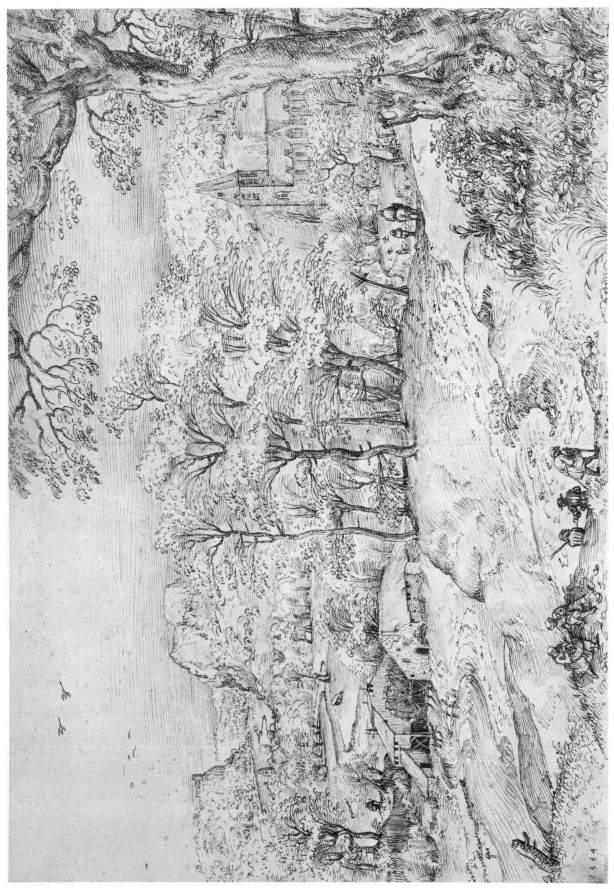

Plate 53. *Bruegel*

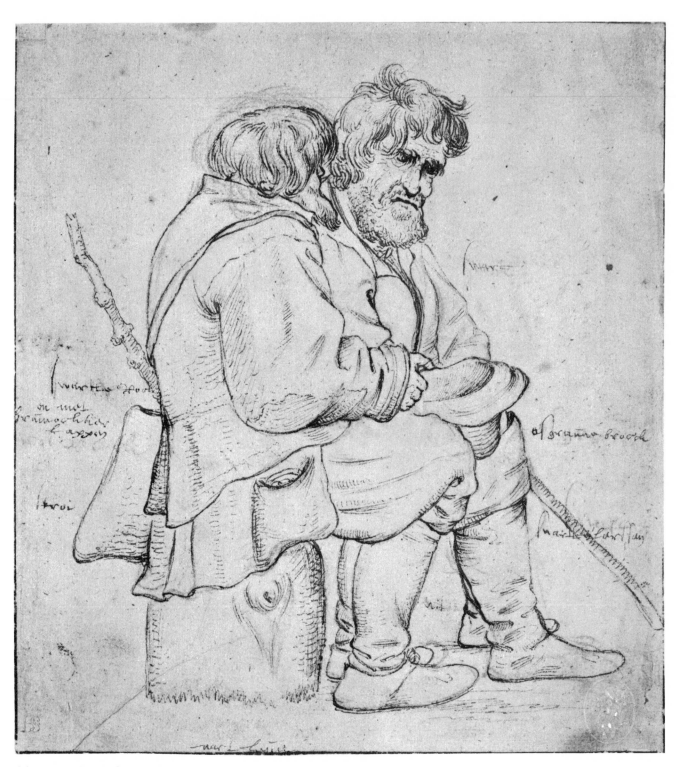

Plate 54. *Bruegel*

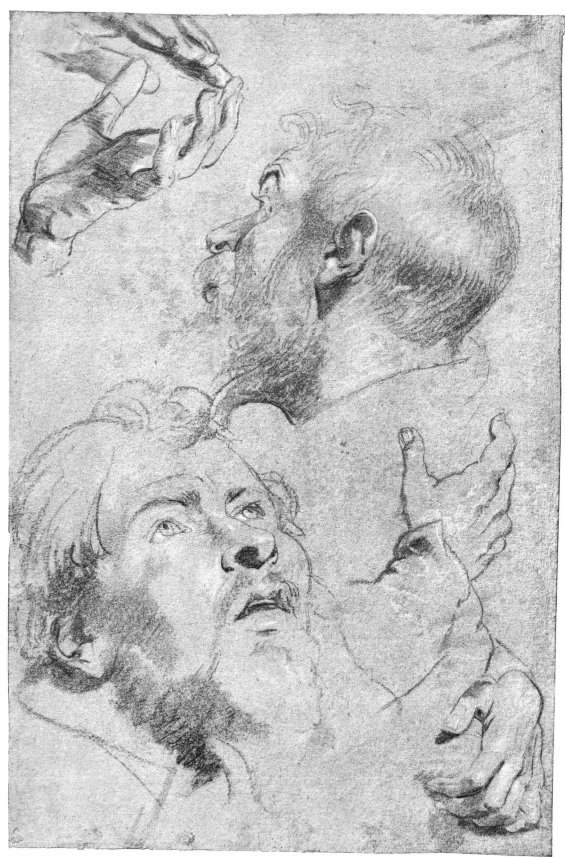

Plate 55. *Peter Paul Rubens*

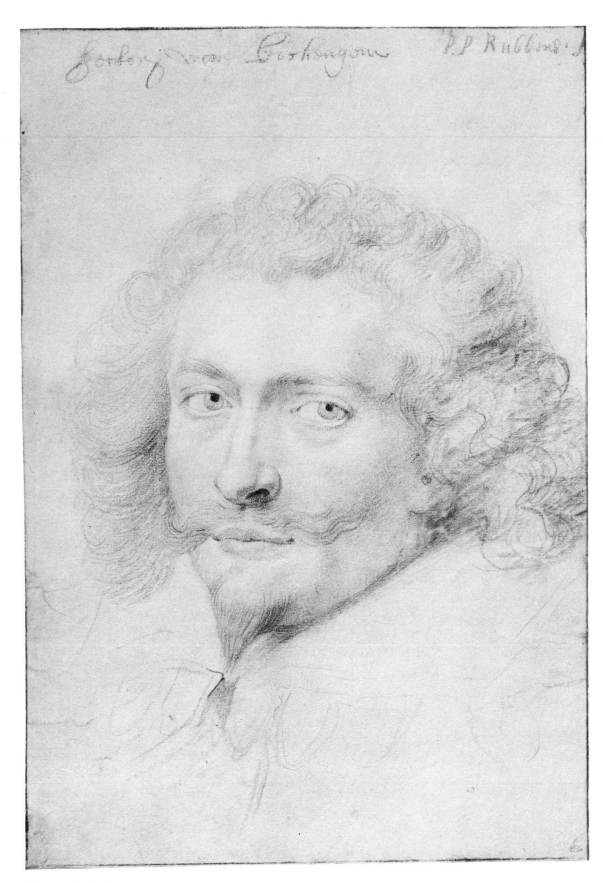

Plate 56. *Rubens*

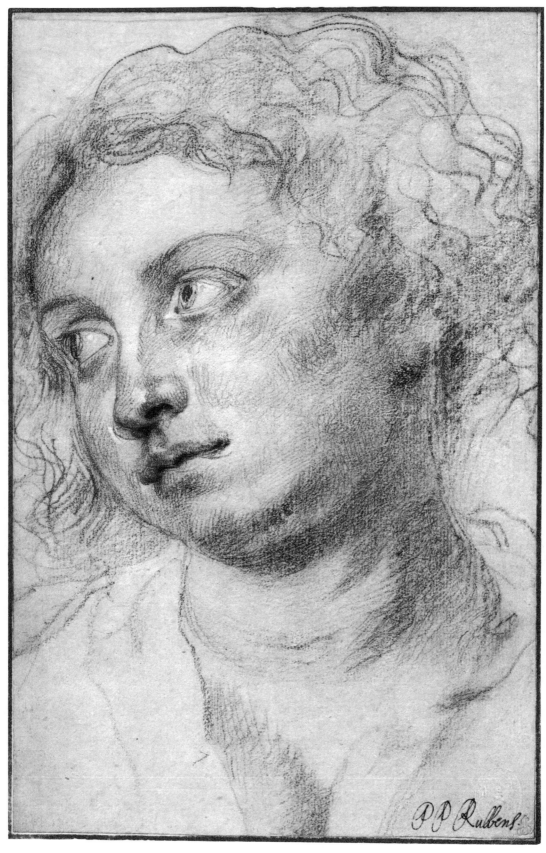

Plate 57. *Rubens*

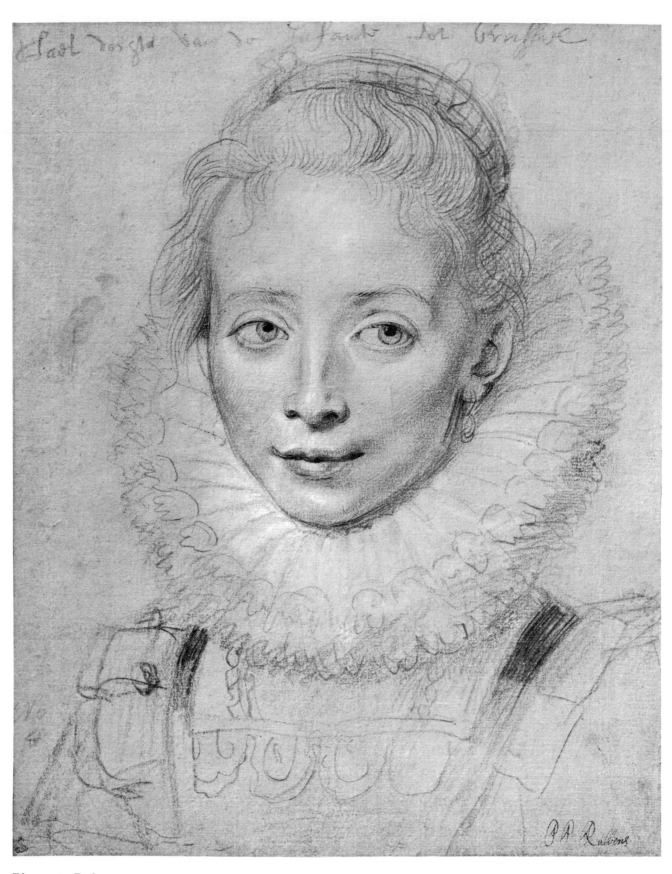

Plate 58. *Rubens*

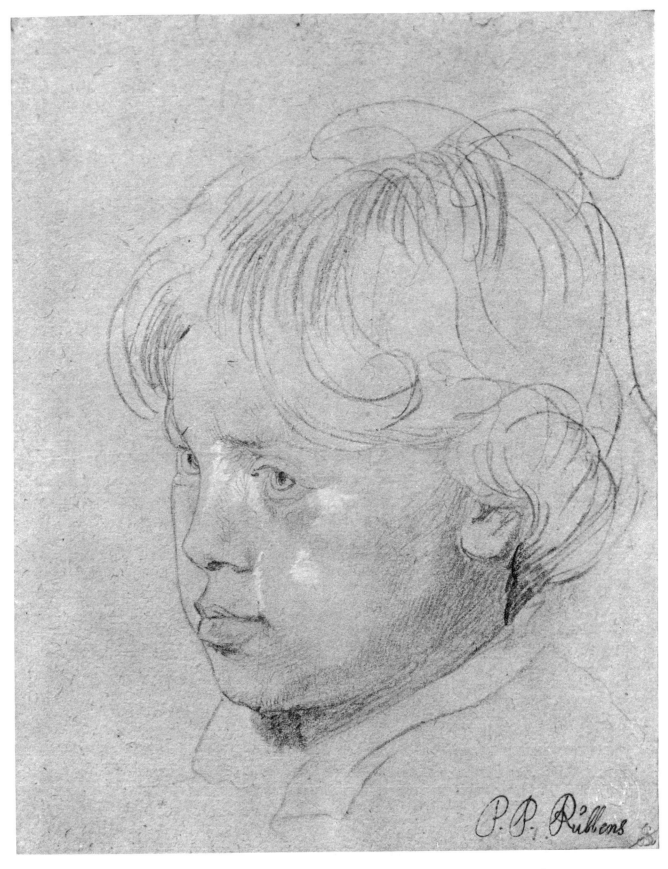

Plate 59. *Rubens*

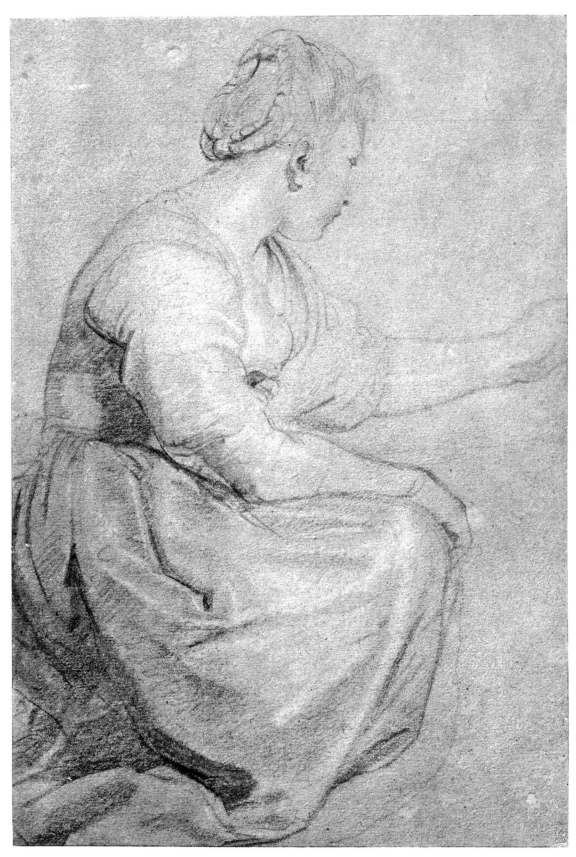

Plate 60. *Rubens*

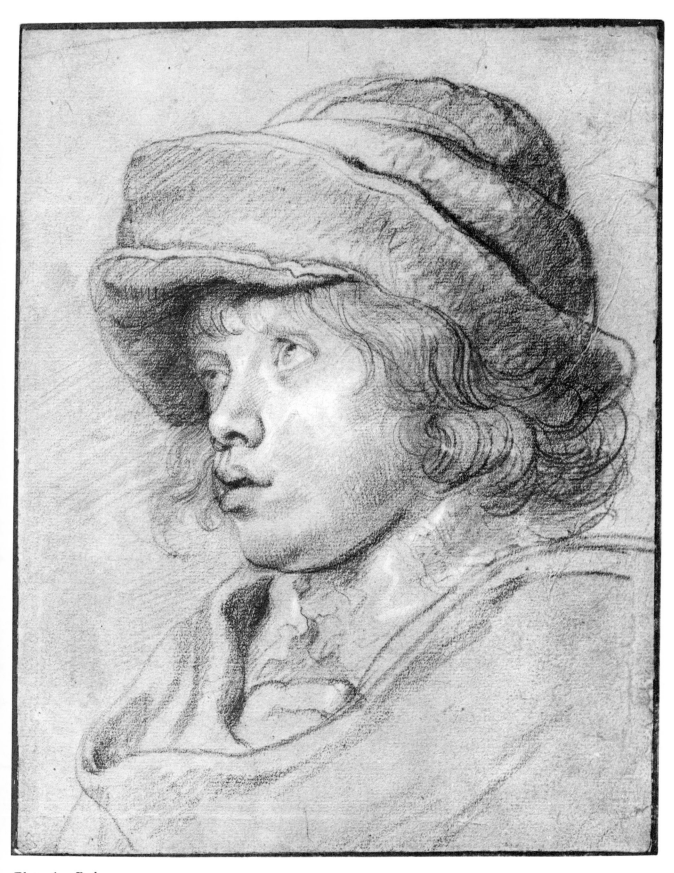

Plate 61. *Rubens*

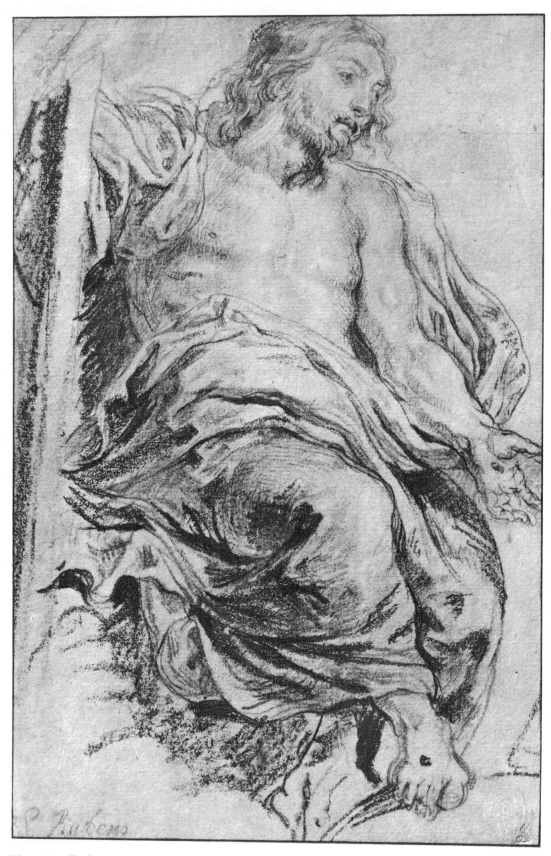

Plate 62. *Rubens*

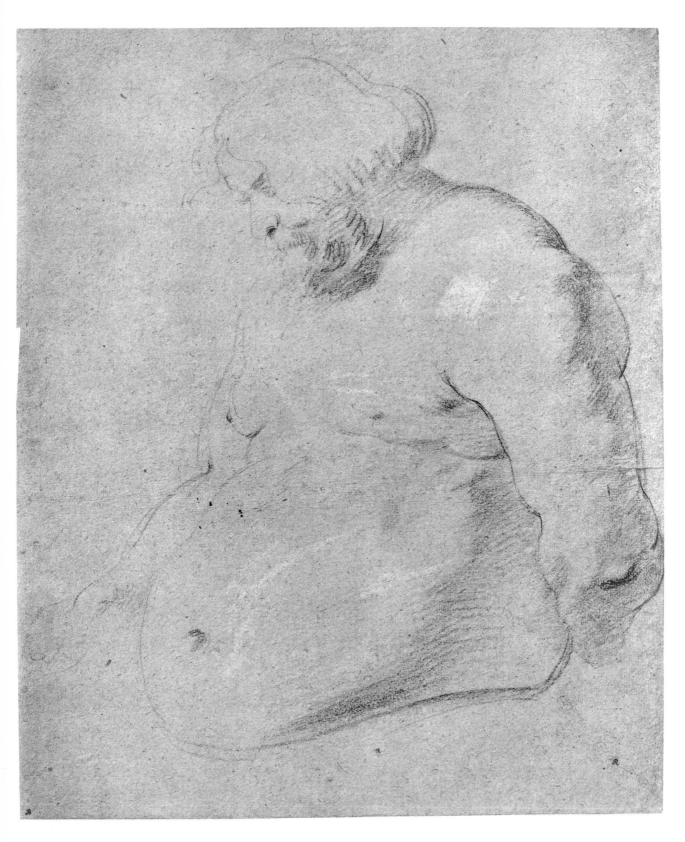

Plate 63. *Rubens*

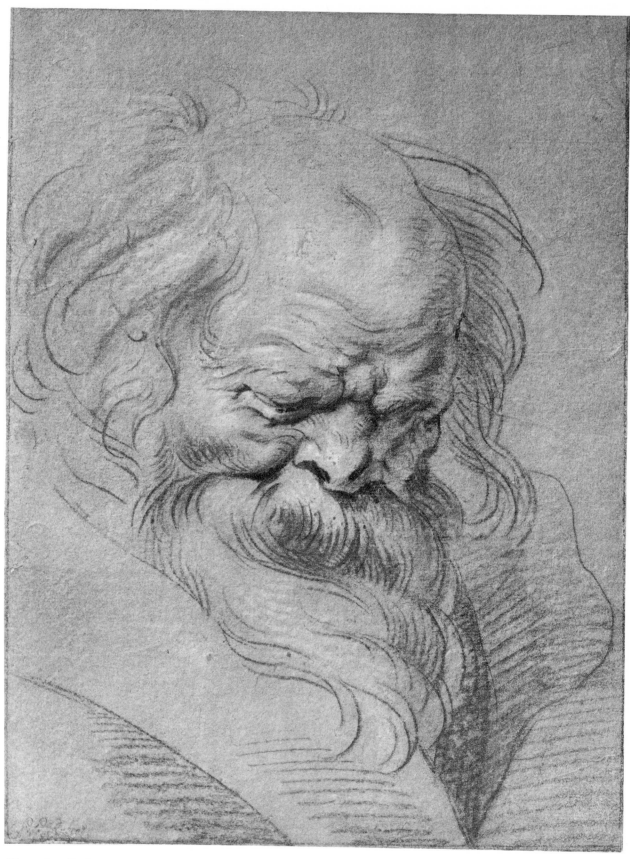

Plate 64. *Rubens*

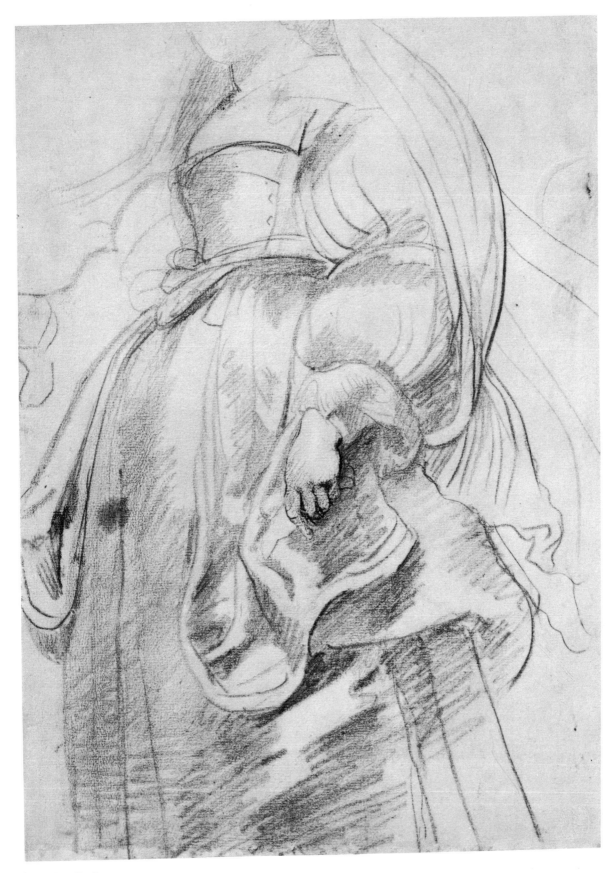

Plate 65. *Rubens*

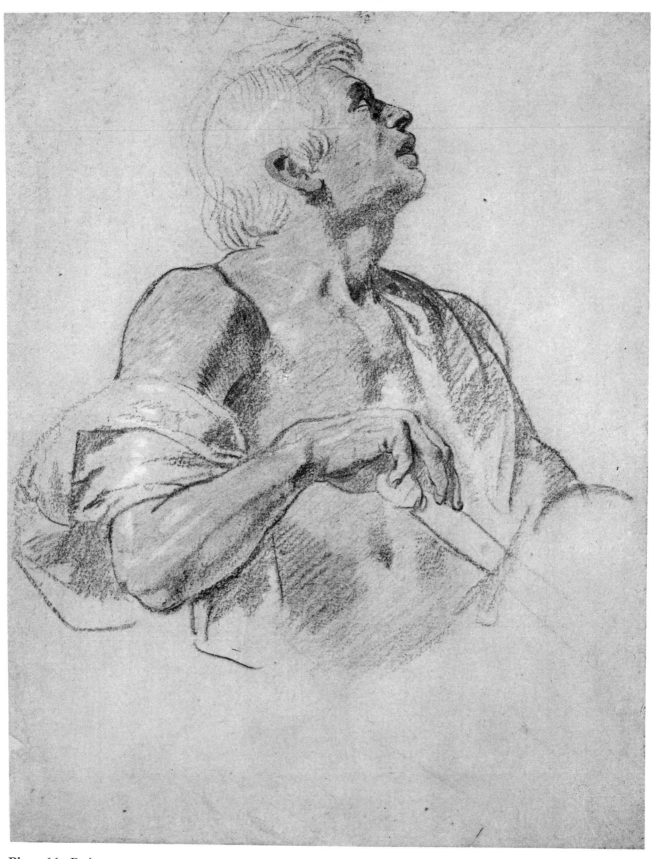

Plate 66. *Rubens*

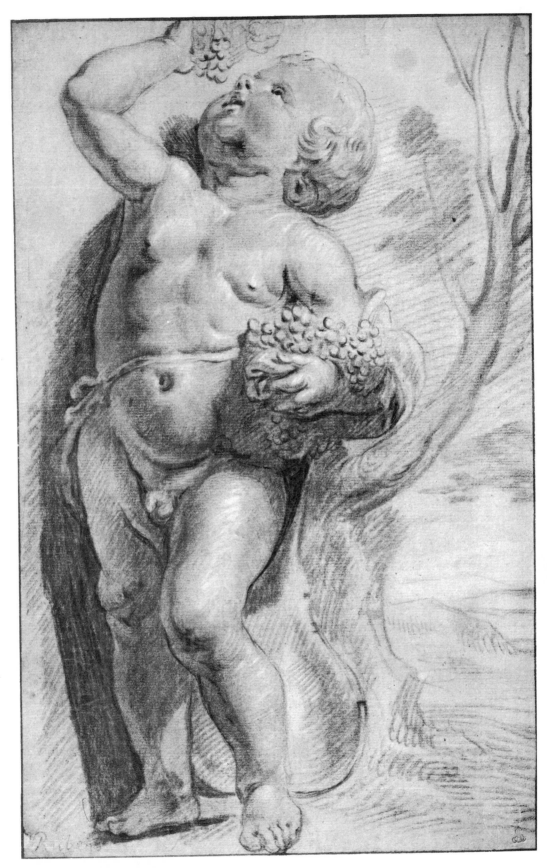

Plate 67. *Rubens*

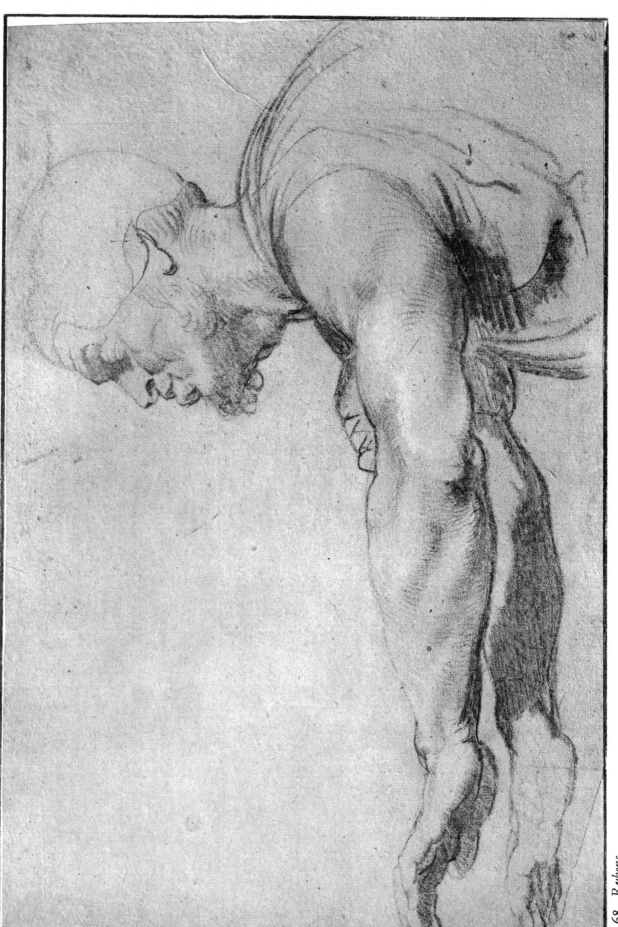

Plate 68. *Rubens*

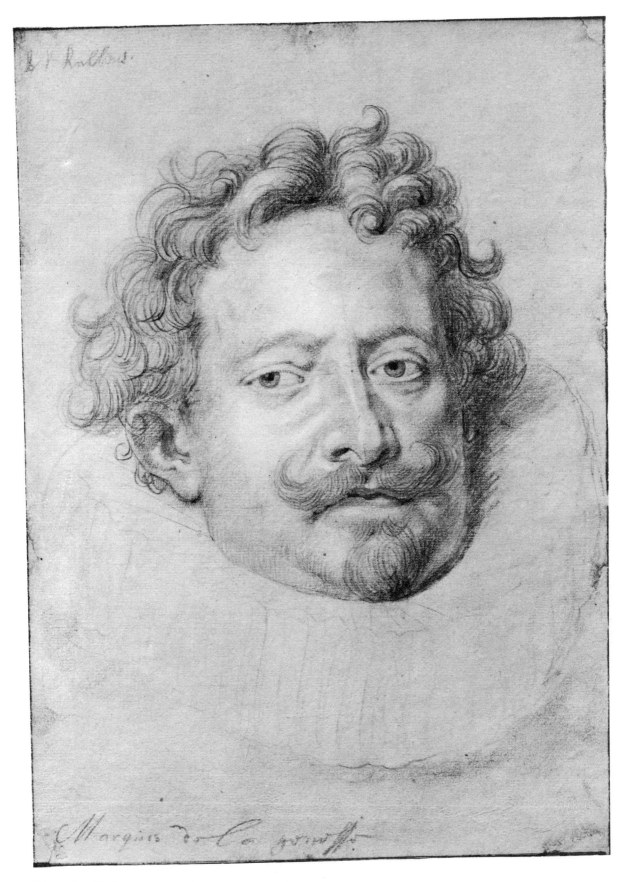

Plate 69. *Rubens*

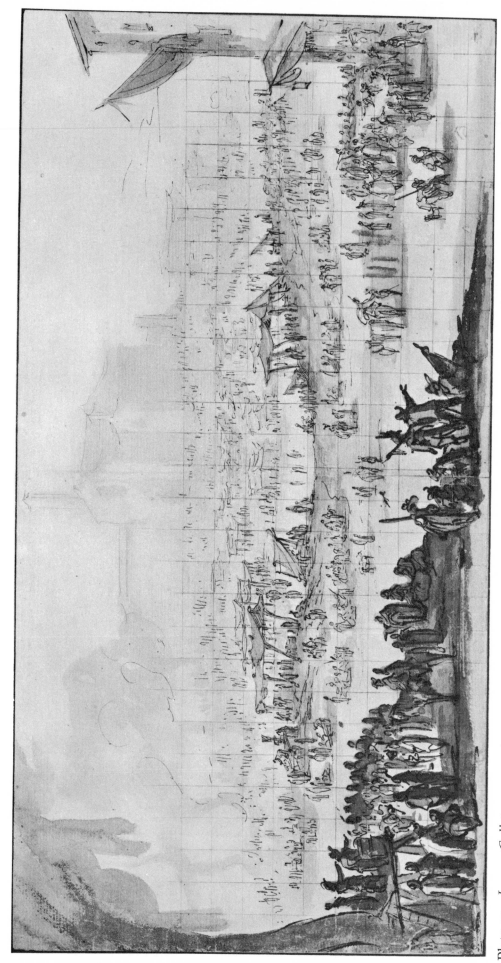

Plate 70. *Jacques Callot*

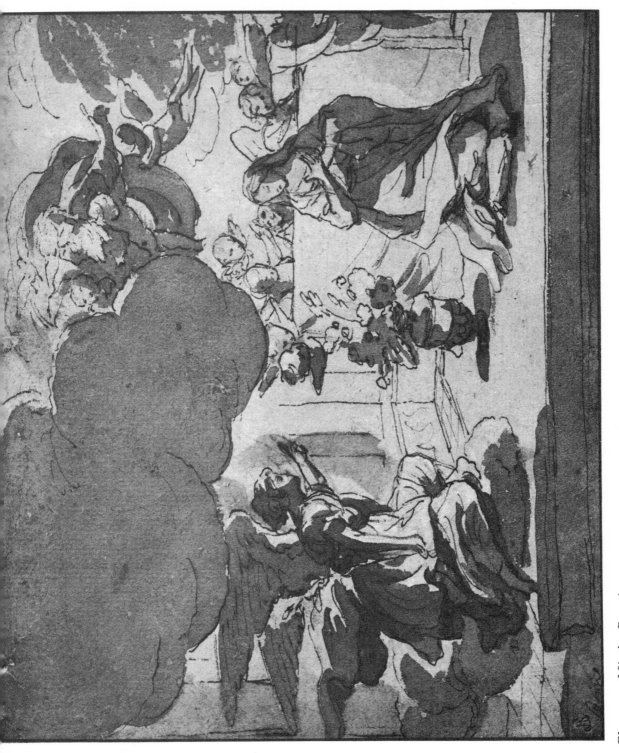

Plate 71. *Nicolas Poussin*

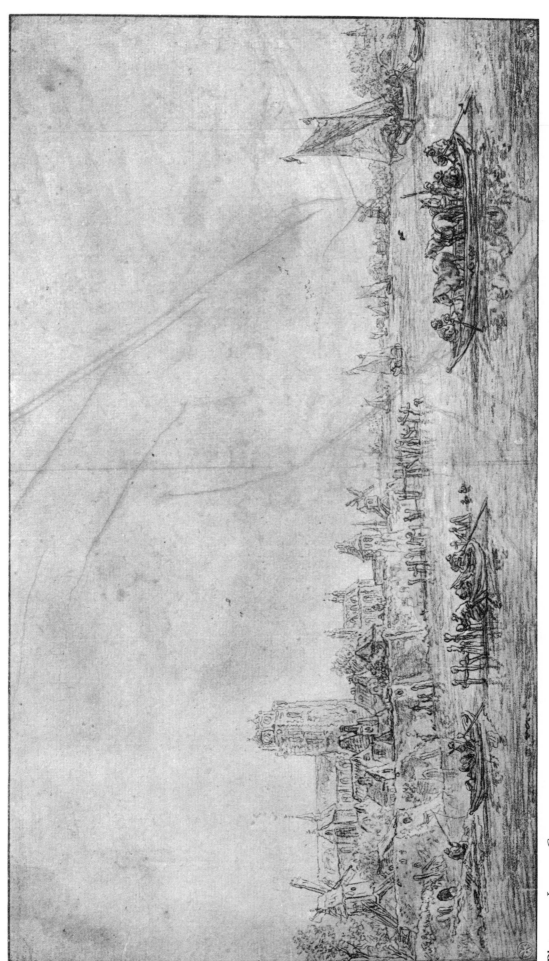

Plate 72. *Ian van Goyen*

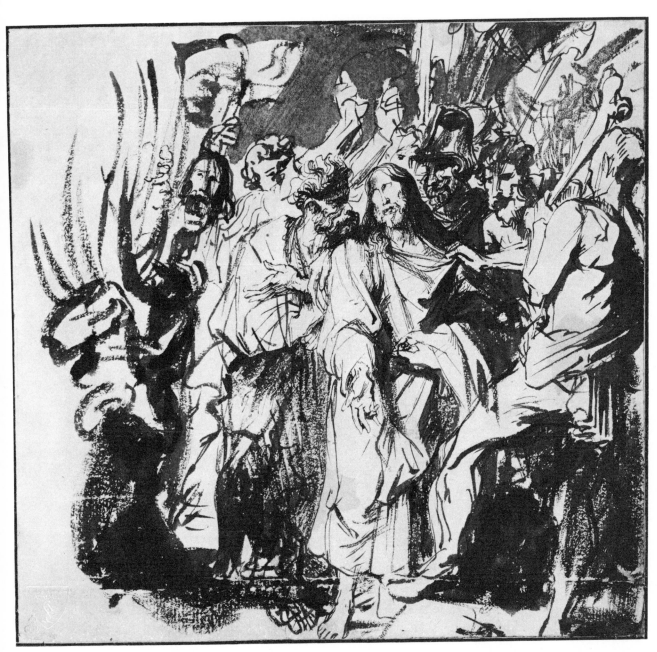

Plate 73. *Anthonis van Dyck*

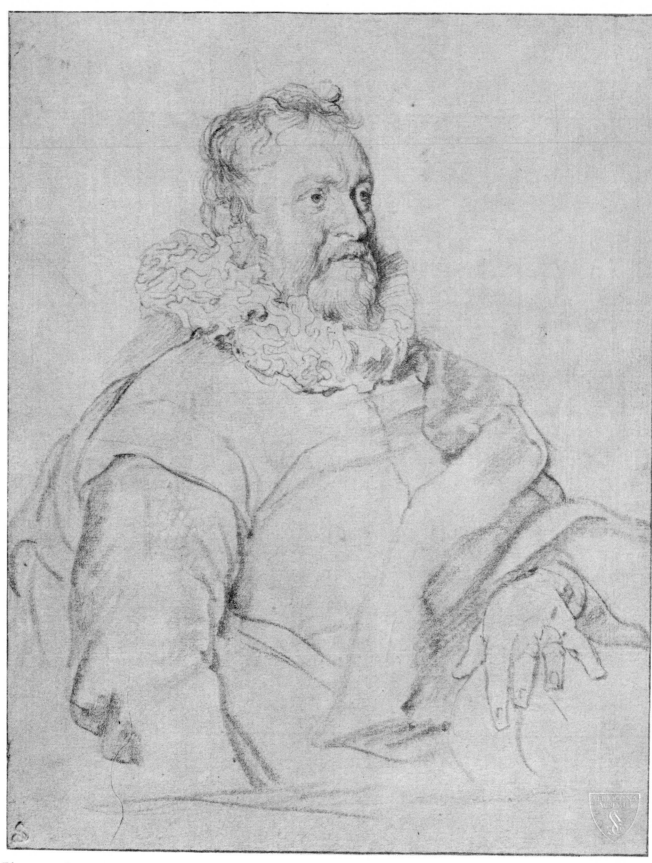

Plate 74. *Van Dyck*

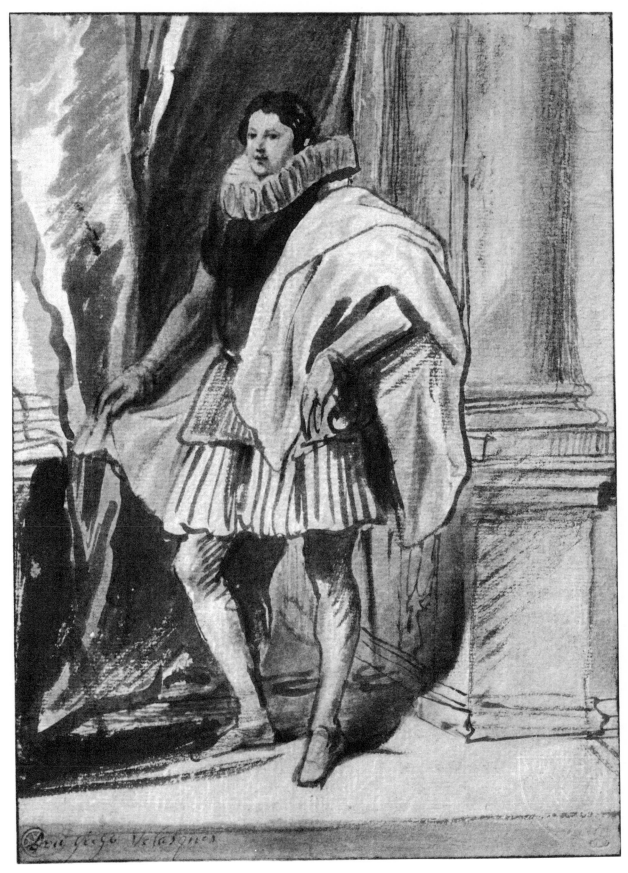

Plate 75. *Van Dyck*

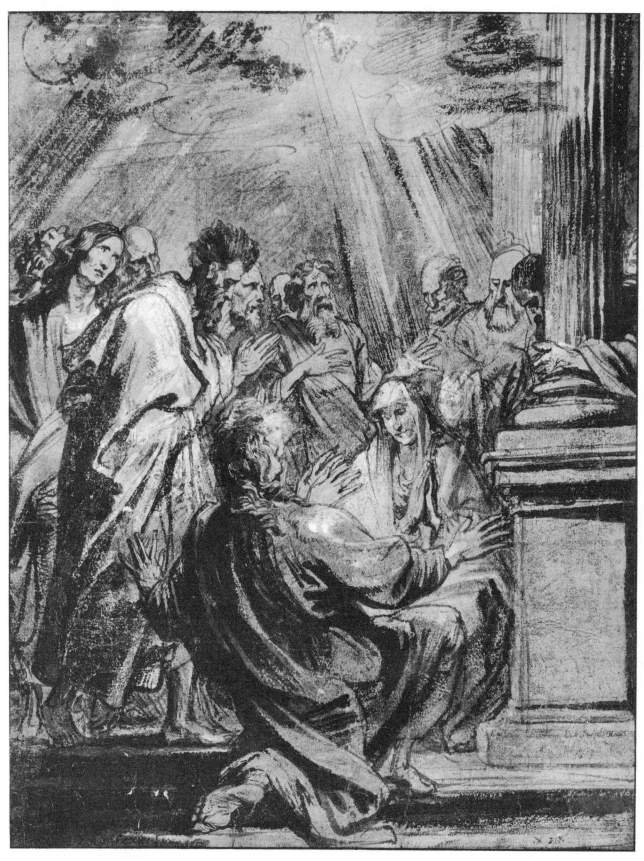

Plate 76. *Van Dyck*

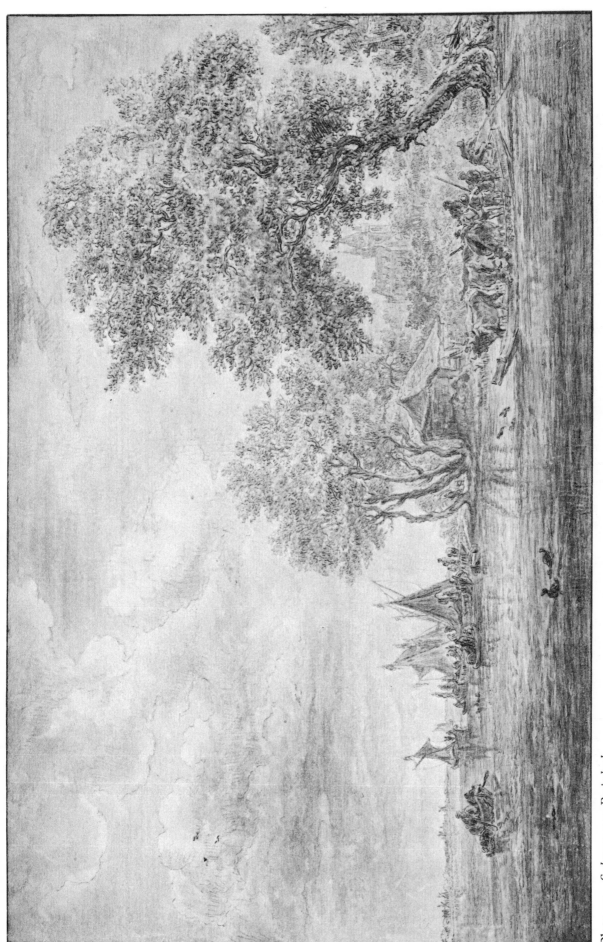

Plate 77. *Salomon van Ruisdael*

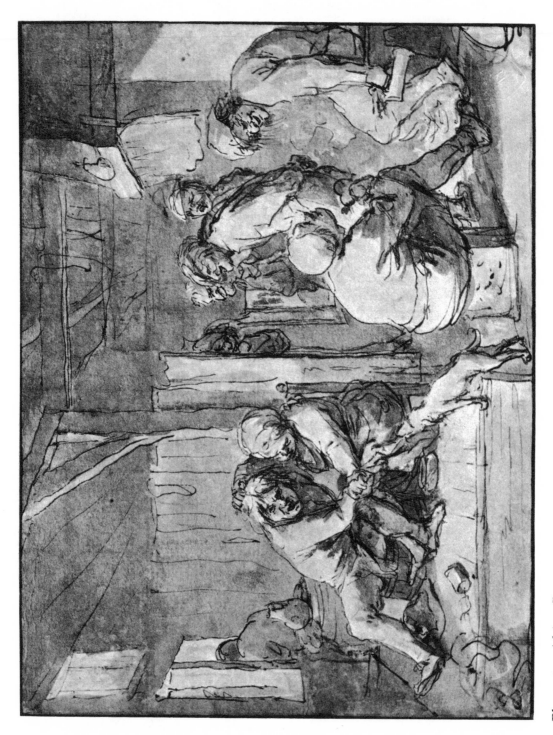

Plate 78. *Adriaen Brouwer*

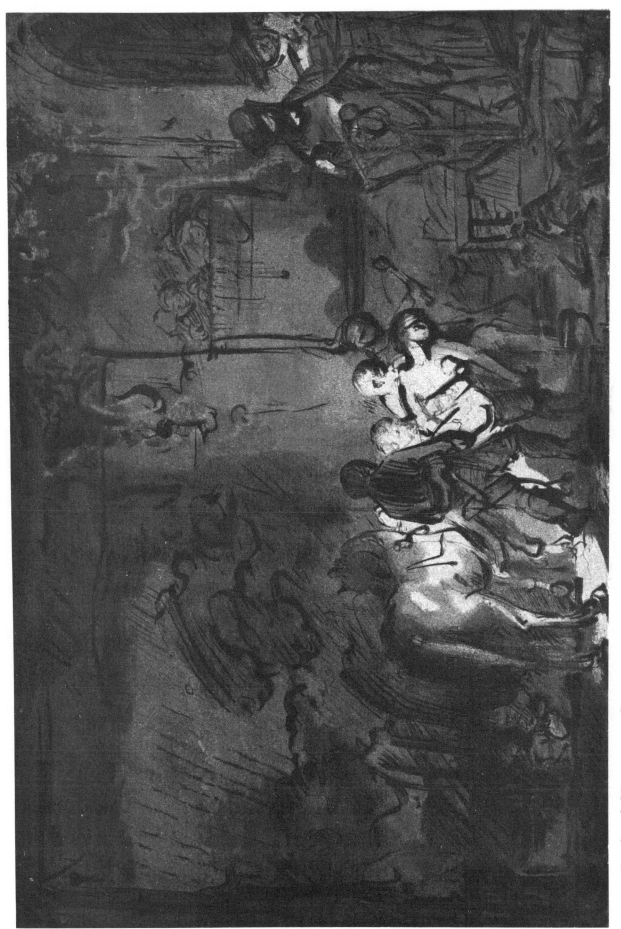

Plate 79. *Rembrandt Harmensz van Rijn*

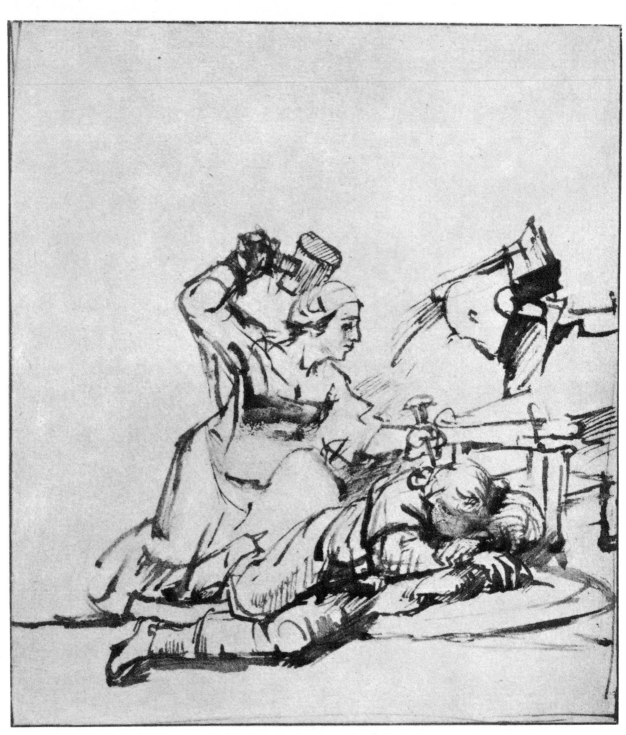

Plate 80. *Rembrandt*

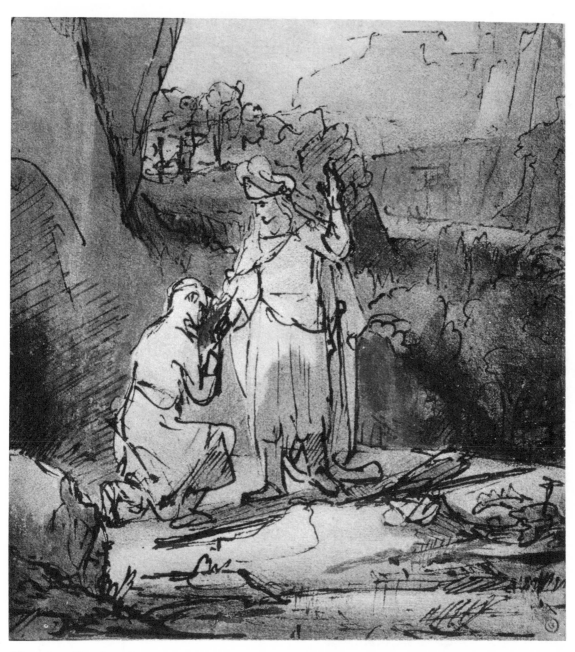

Plate 81. *Rembrandt*

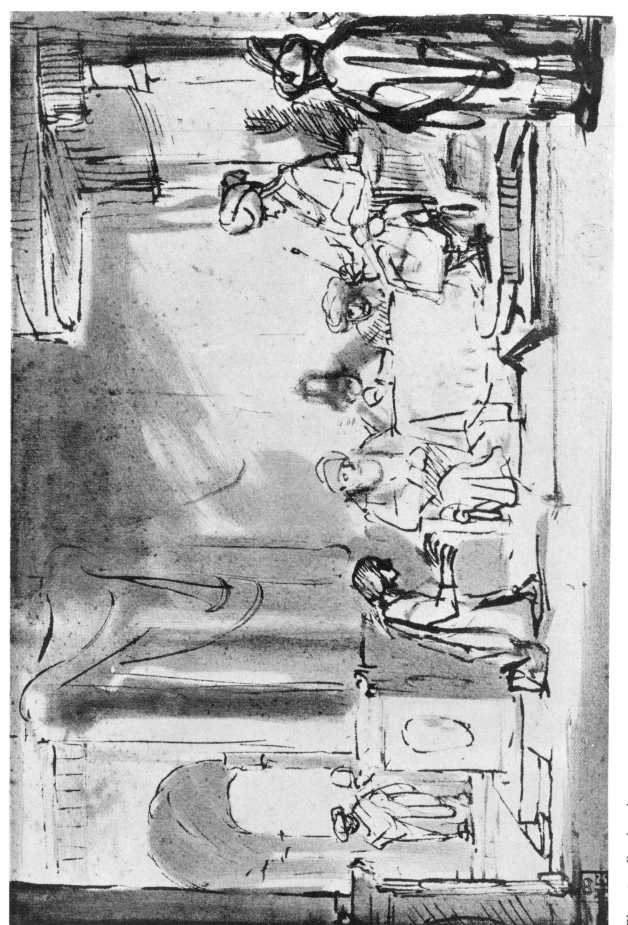

Plate 82. *Rembrandt*

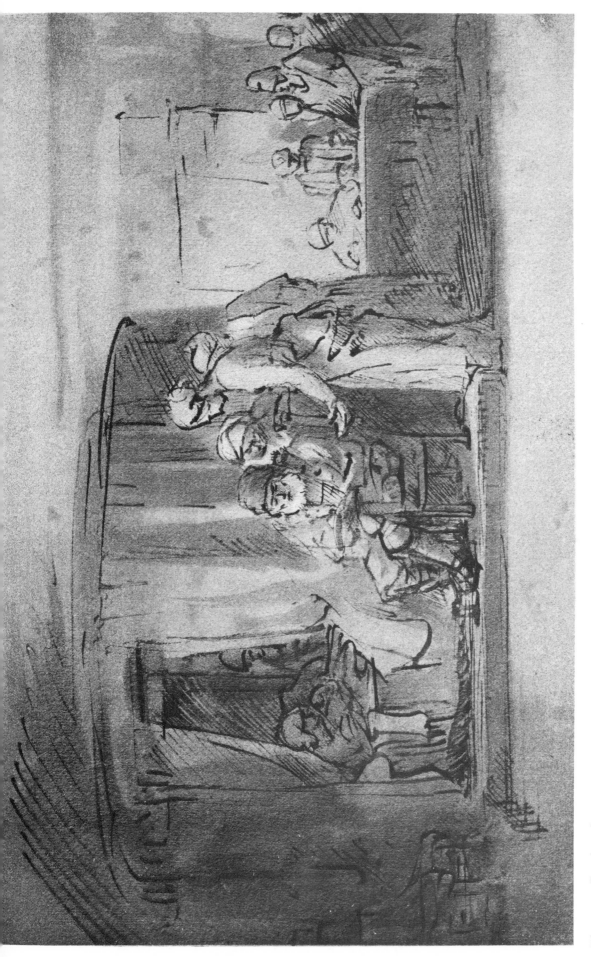

Plate 83. *Rembrandt*

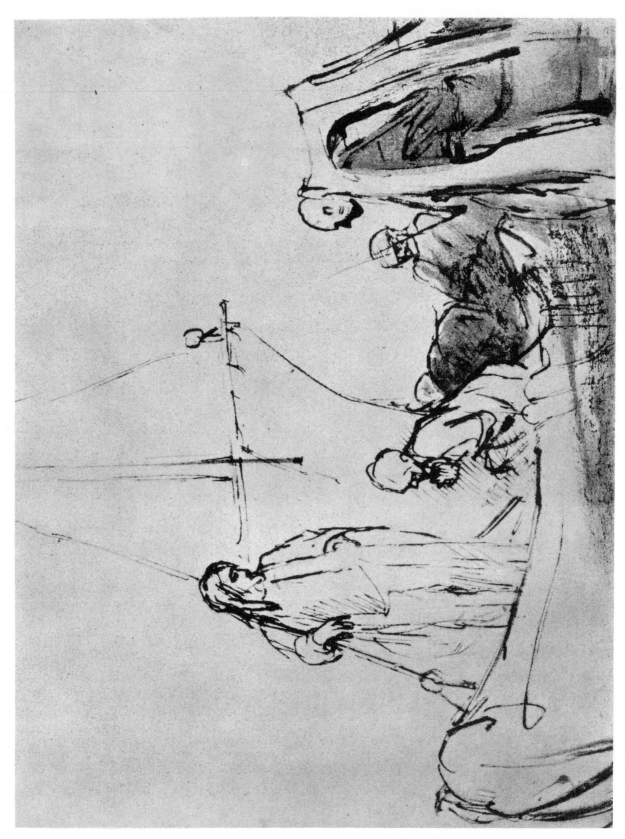

Plate 84. *Rembrandt*

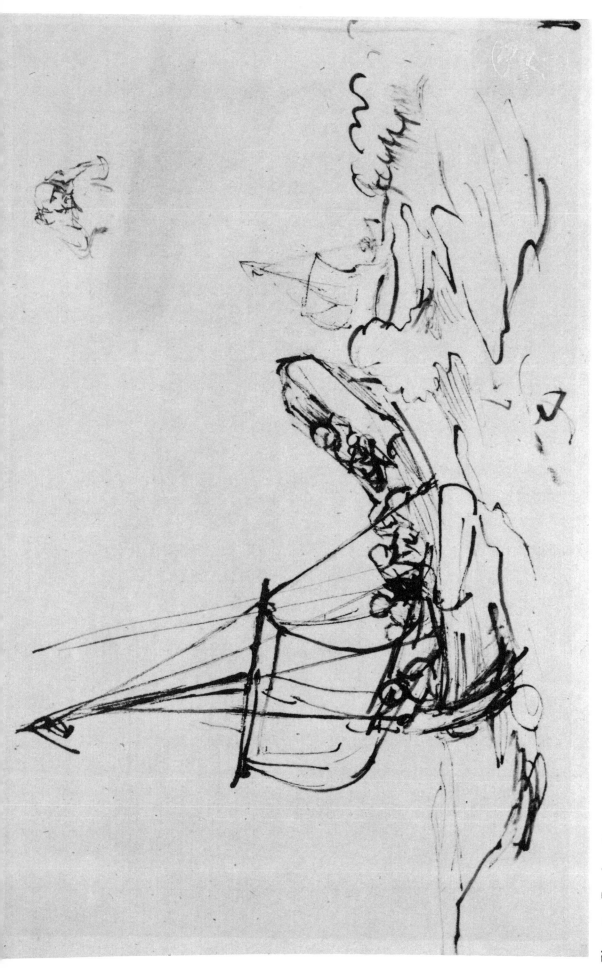

Plate 85. *Rembrandt*

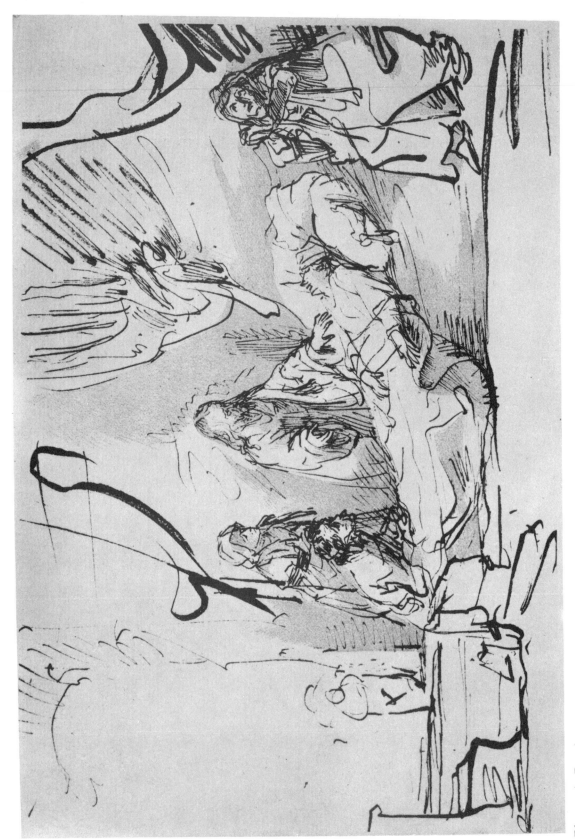

Plate 86. *Rembrandt*

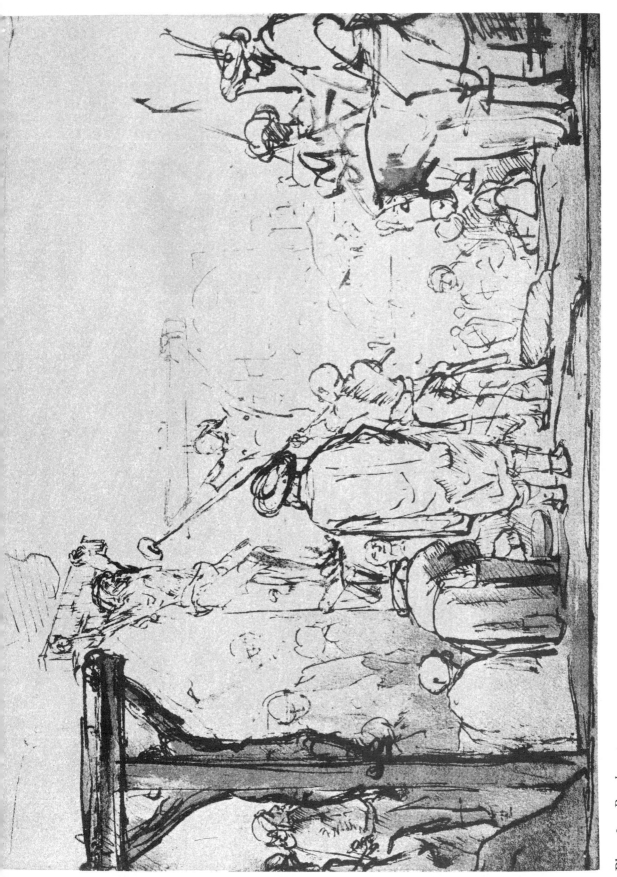

Plate 87. *Rembrandt*

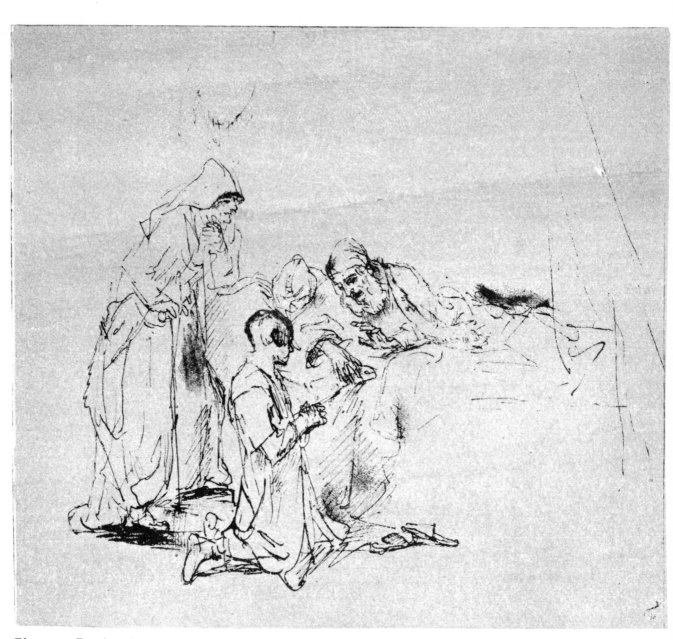

Plate 88. *Rembrandt*

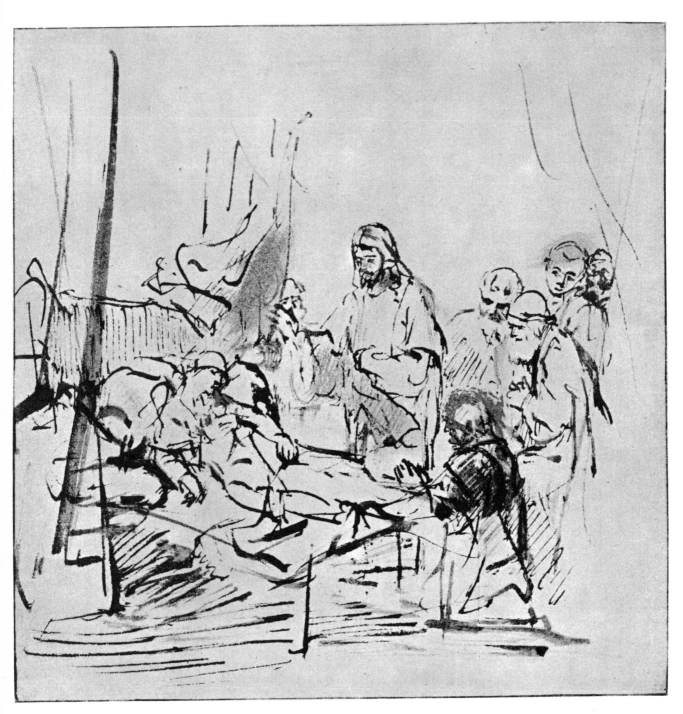

Plate 89. *Rembrandt*

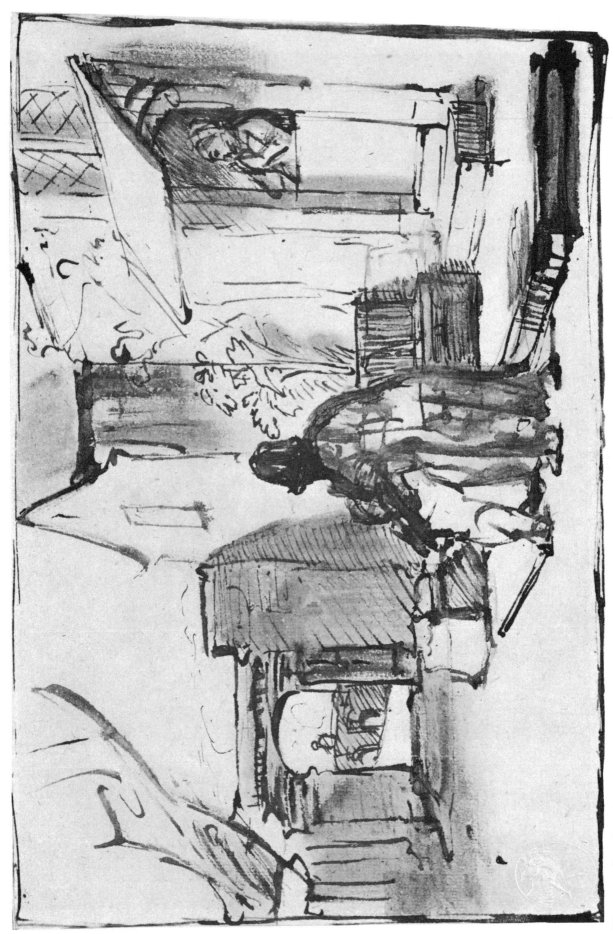

Plate 90. *Rembrandt*

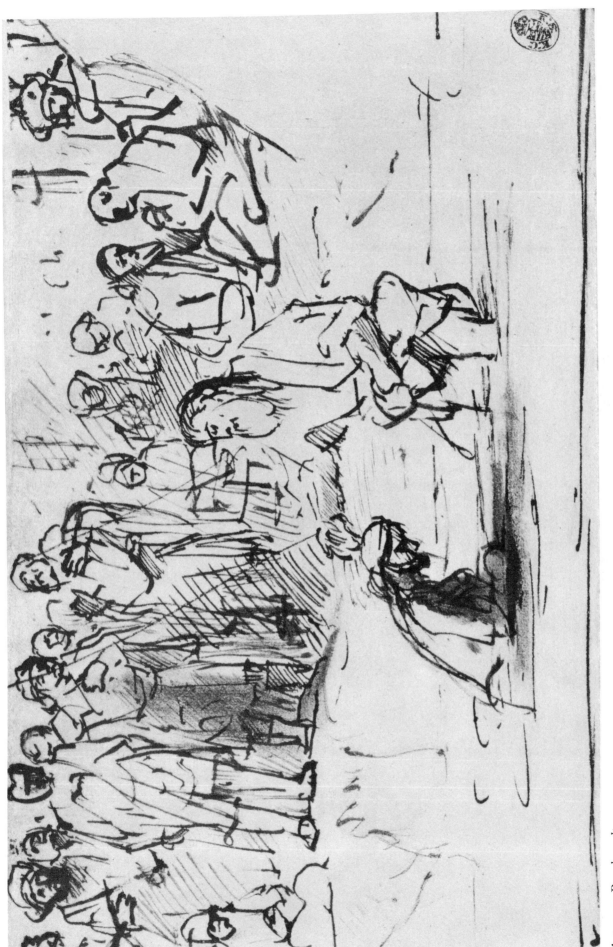

Plate 91. *Rembrandt*

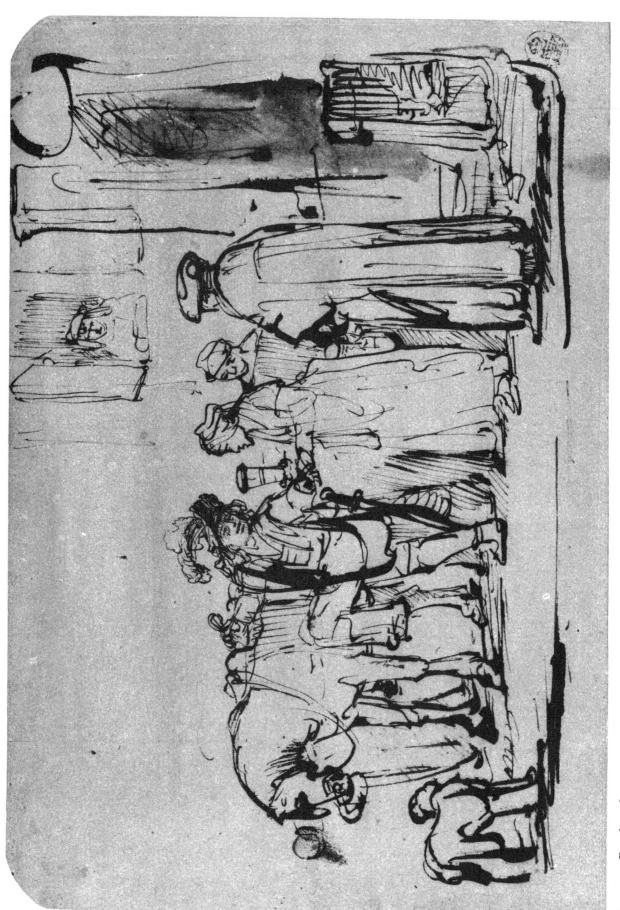

Plate 92. *Rembrandt*

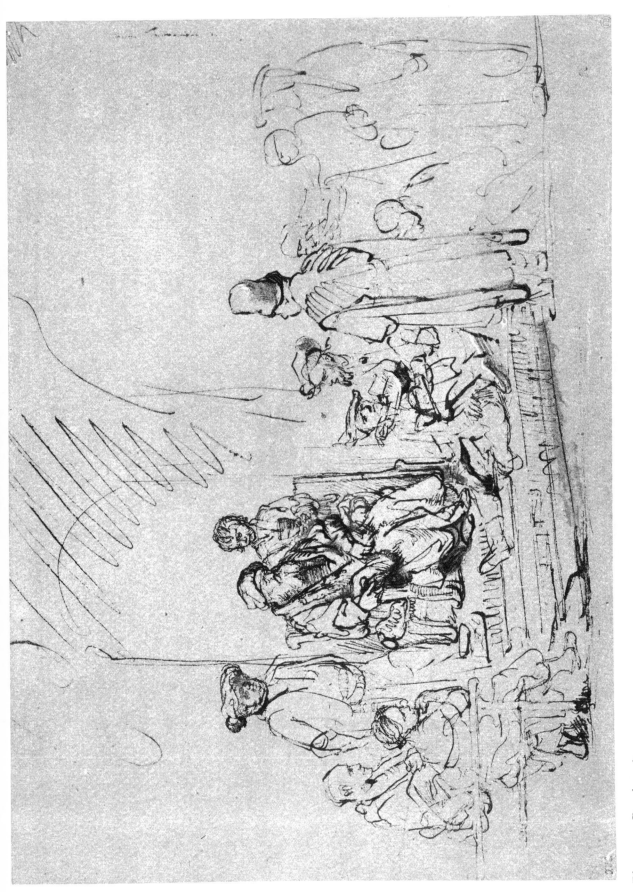

Plate 93. *Rembrandt*

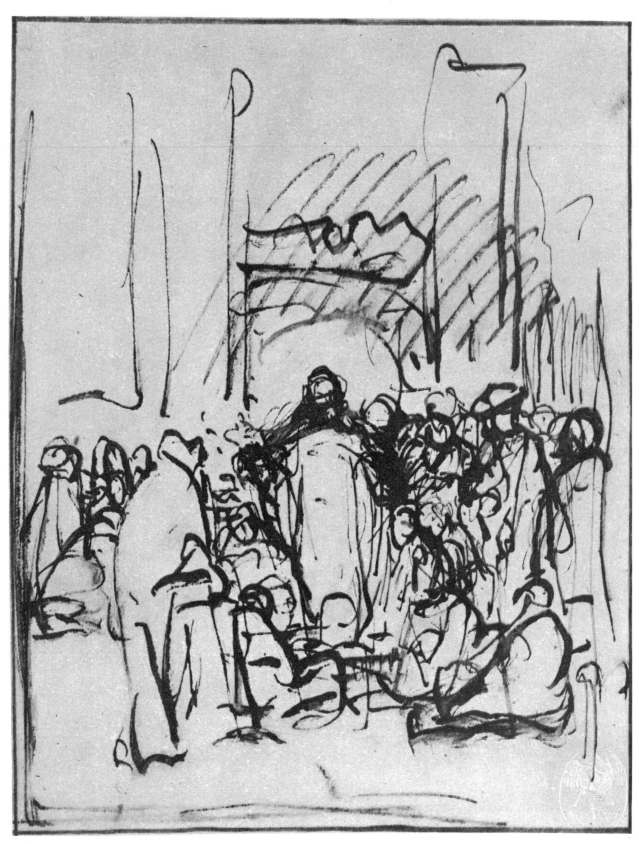

Plate 94. *Rembrandt*

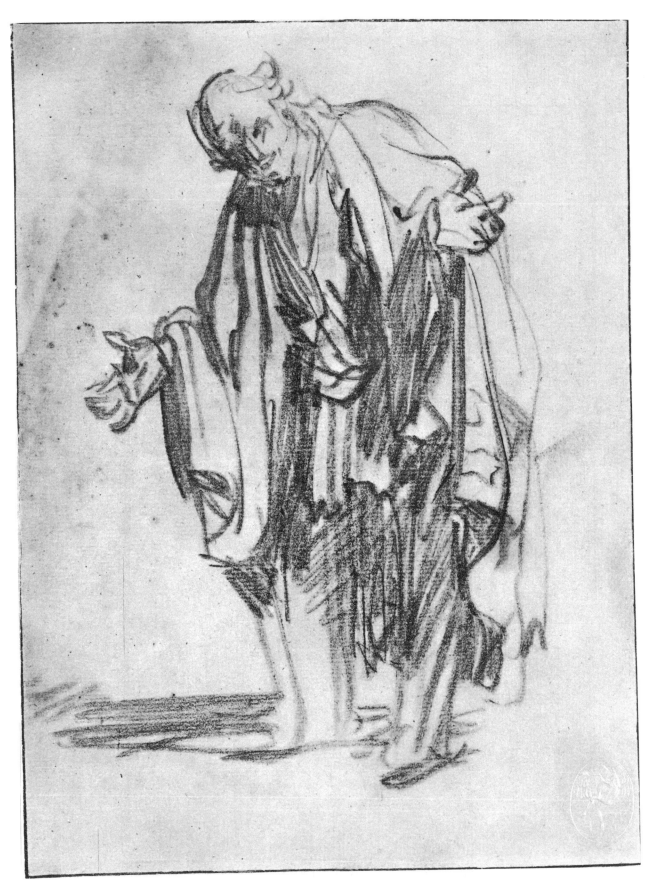

Plate 95. *Rembrandt*

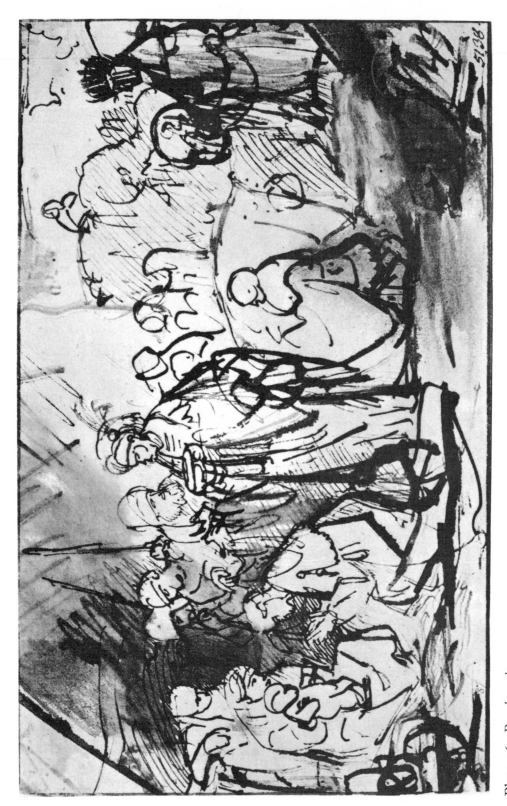

Plate 96. *Rembrandt*

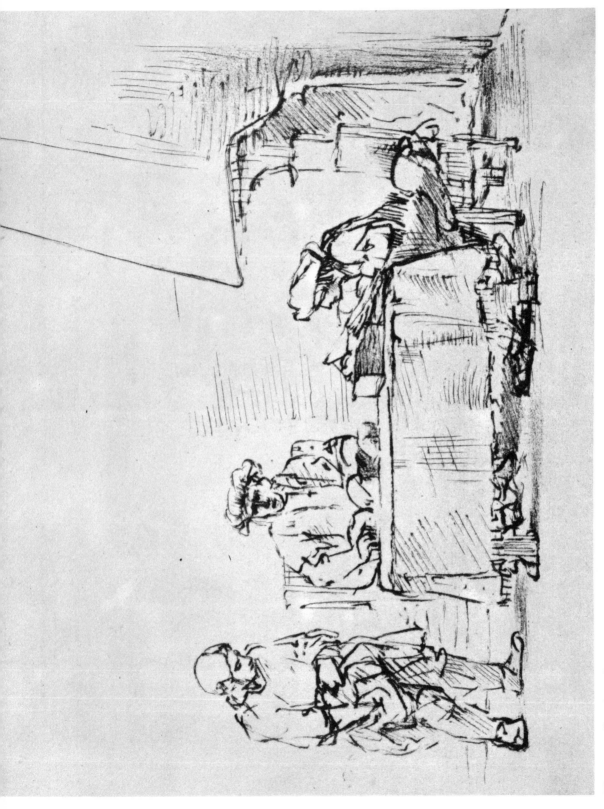

Plate 97. *Rembrandt*

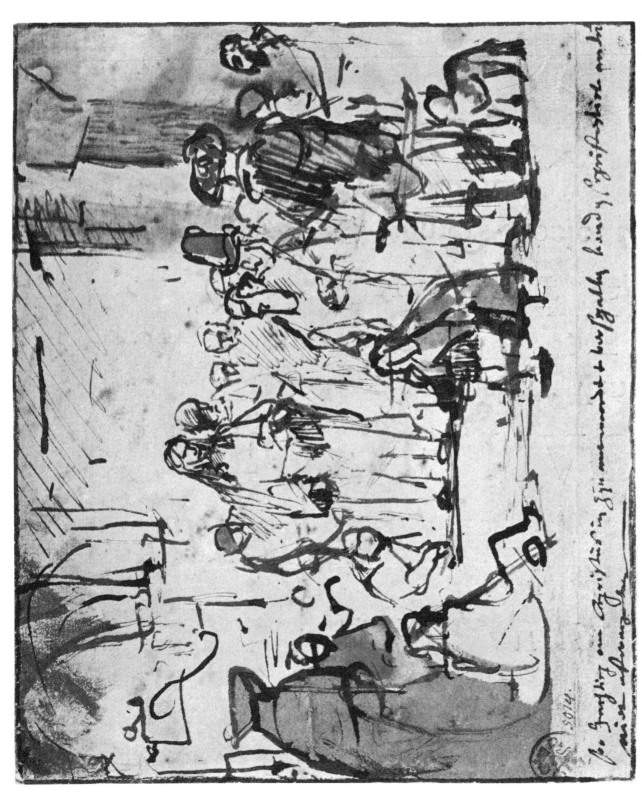

Plate 98. Rembrandt

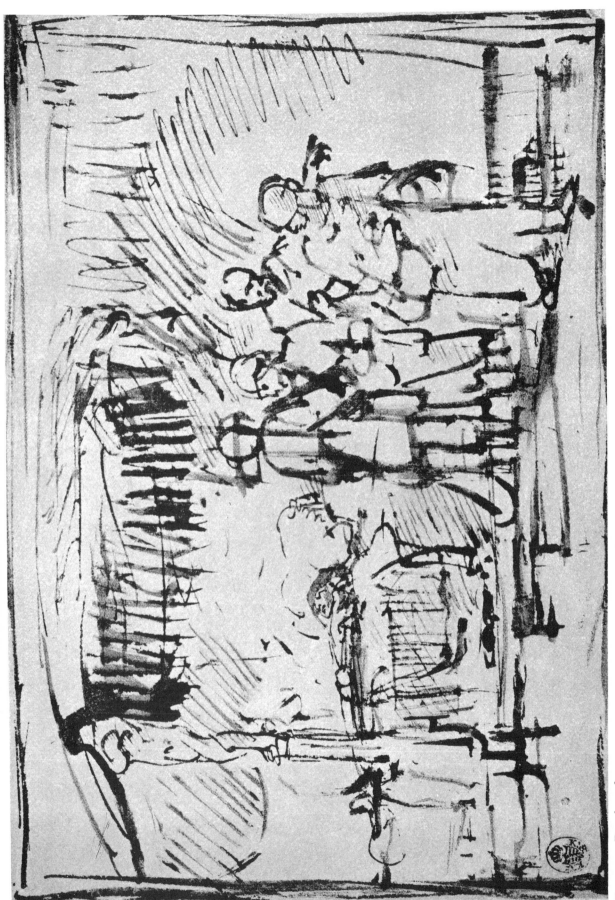

Plate 99. *Rembrandt*

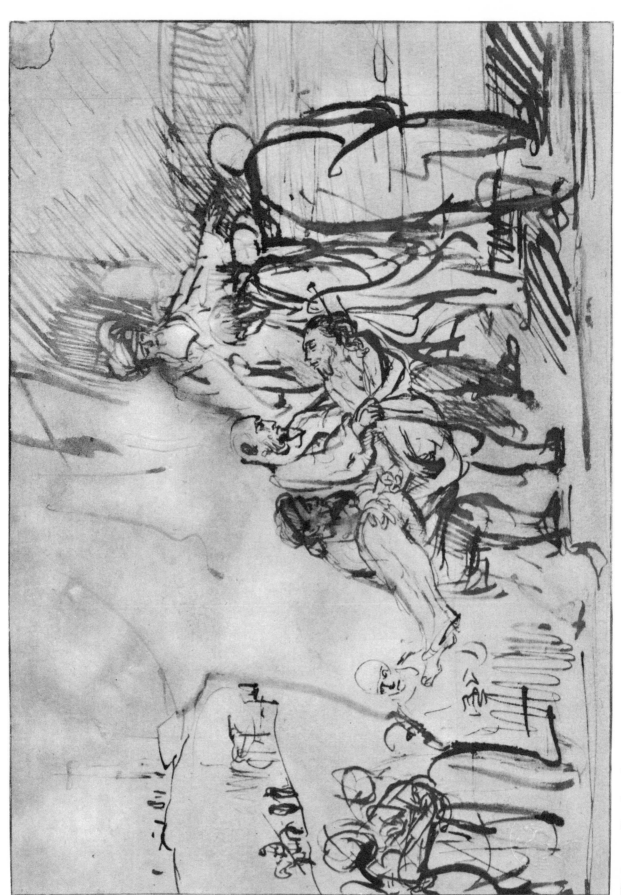

Plate 100. *Rembrandt*

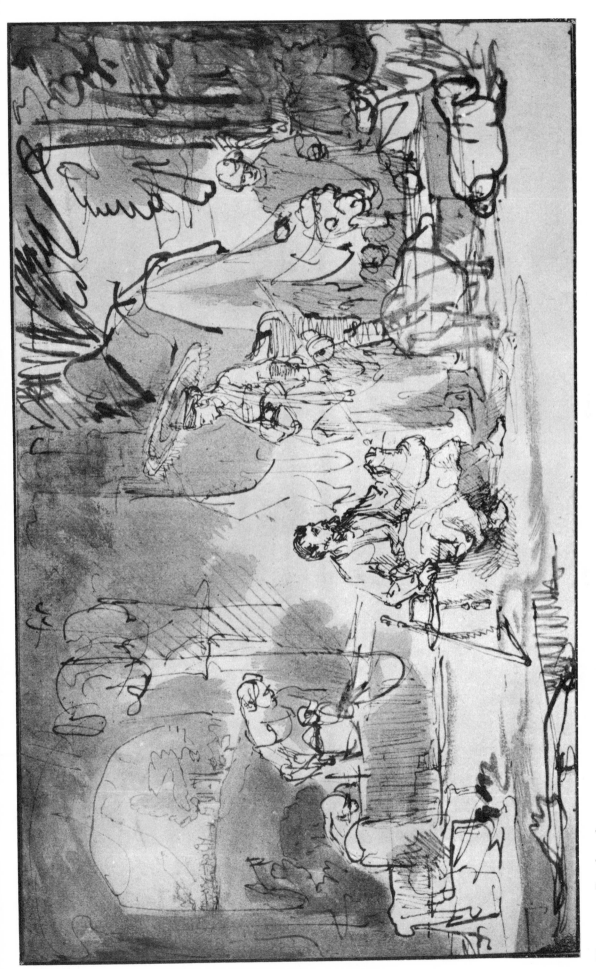

Plate 101. *Rembrandt*

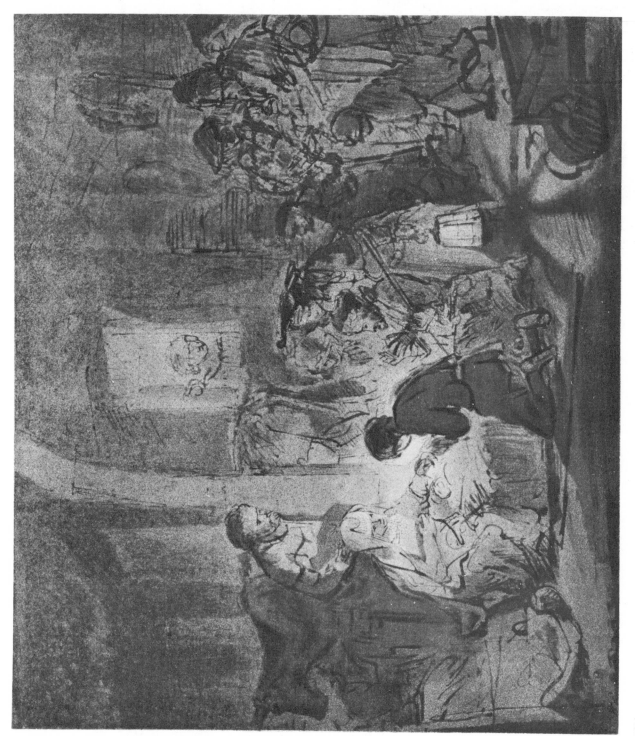

Plate 102. *Rembrandt*

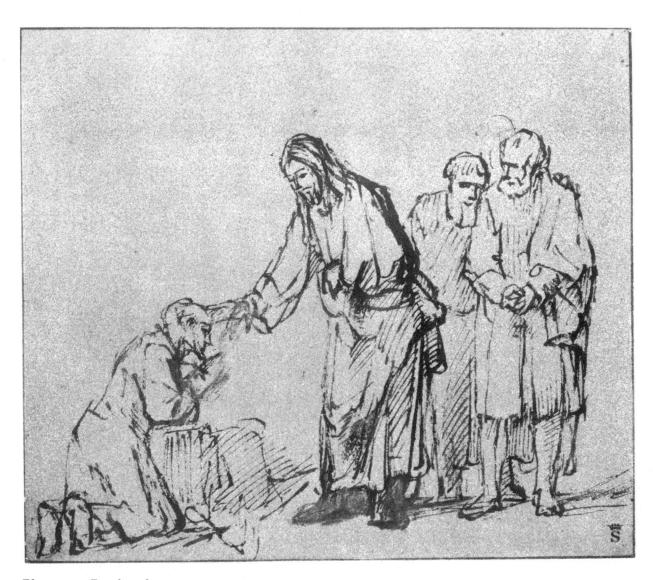

Plate 103. *Rembrandt*

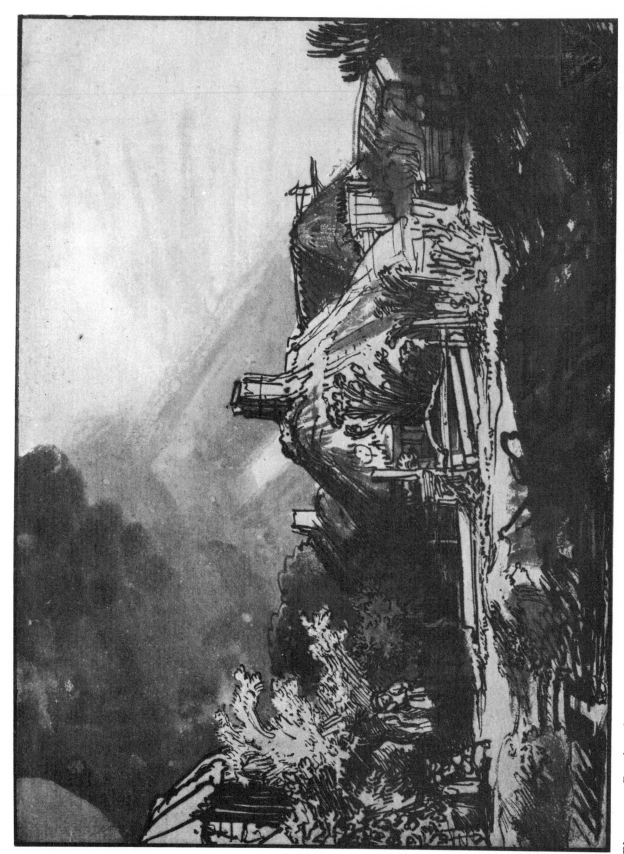

Plate 104. *Rembrandt*

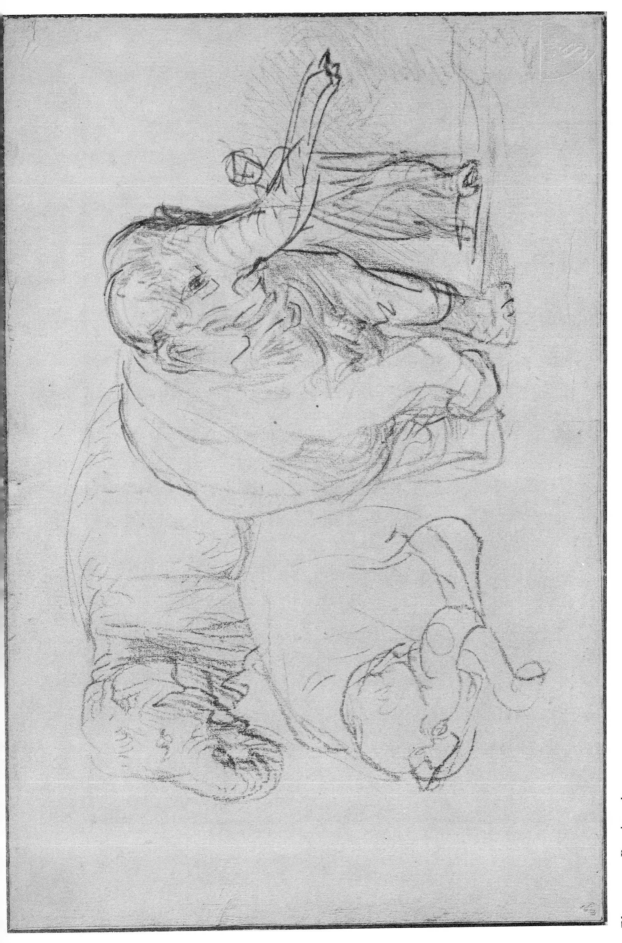

Plate 105. *Rembrandt*

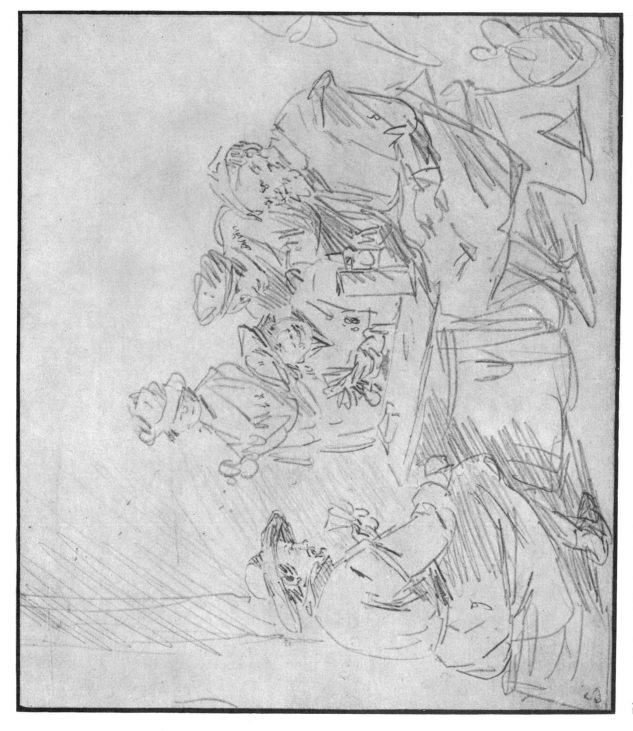

Plate 106. *David Teniers the Younger*

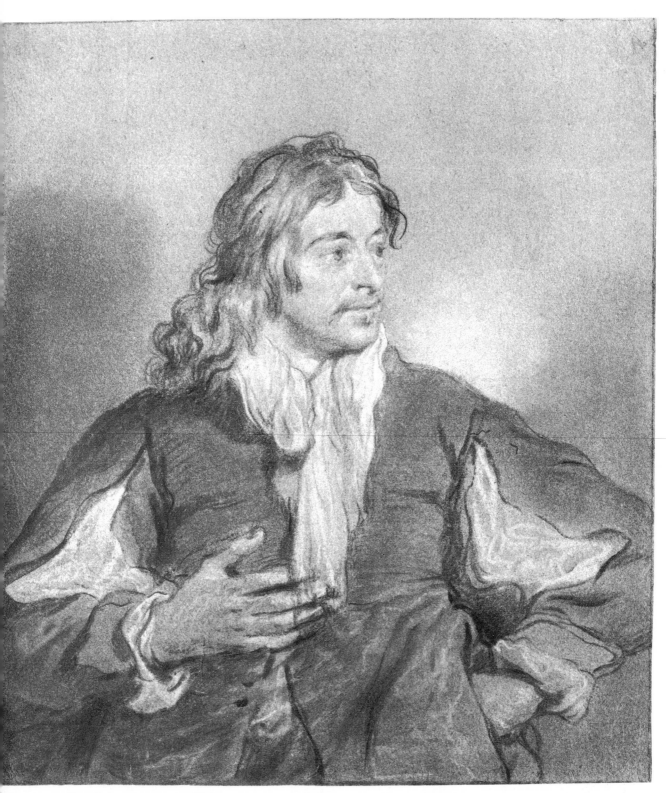

Plate 107. *Bartholomeus van der Helst*

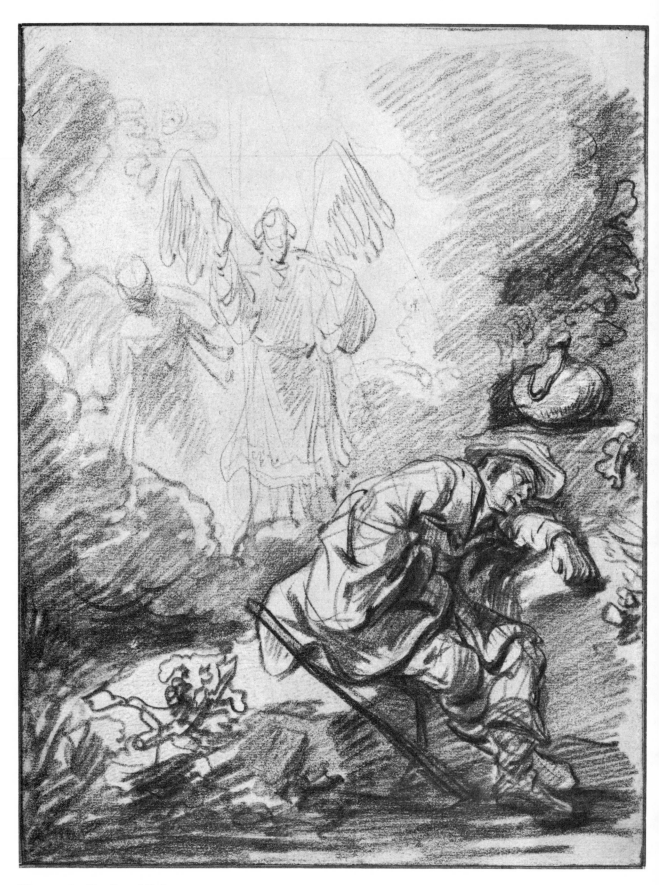

Plate 108. *Ferdinand Bol*

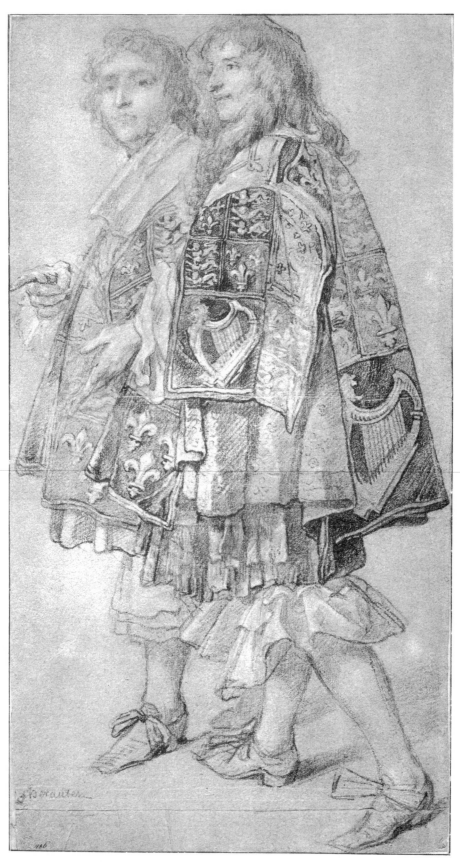

Plate 109. *Sir Peter Lely*

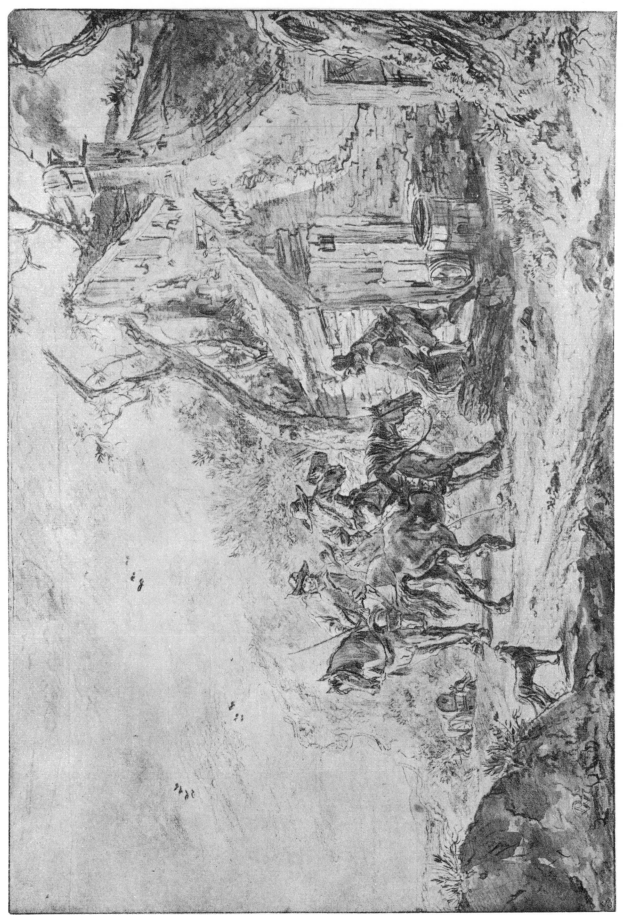

Plate 110. *Philips Wouwerman*

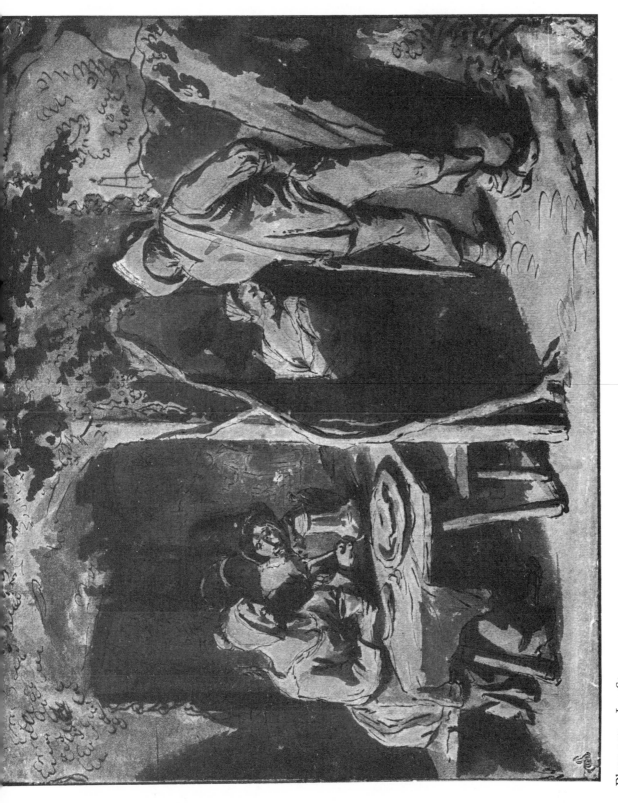

Plate III. *Jan Steen*

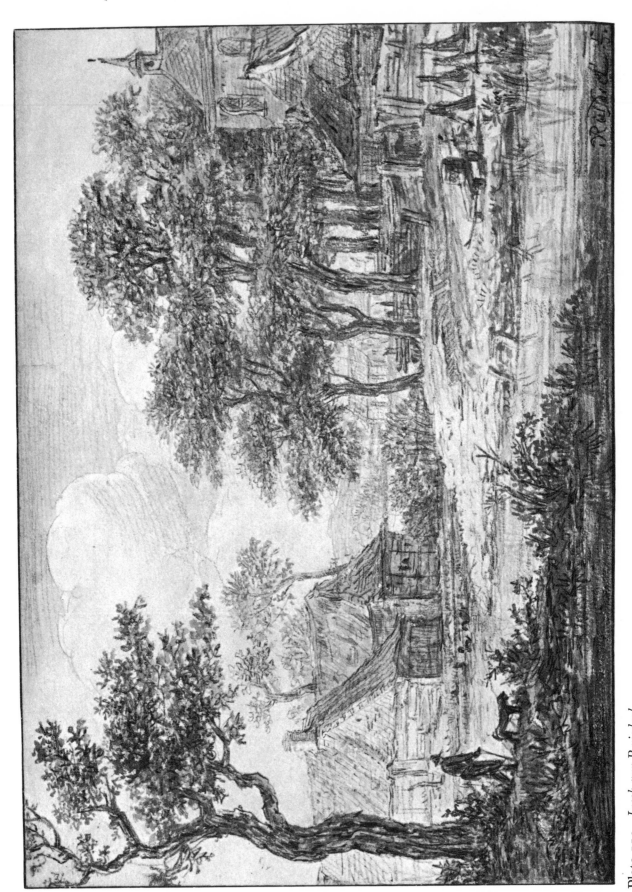

Plate 112. *Jacob van Ruisdael*

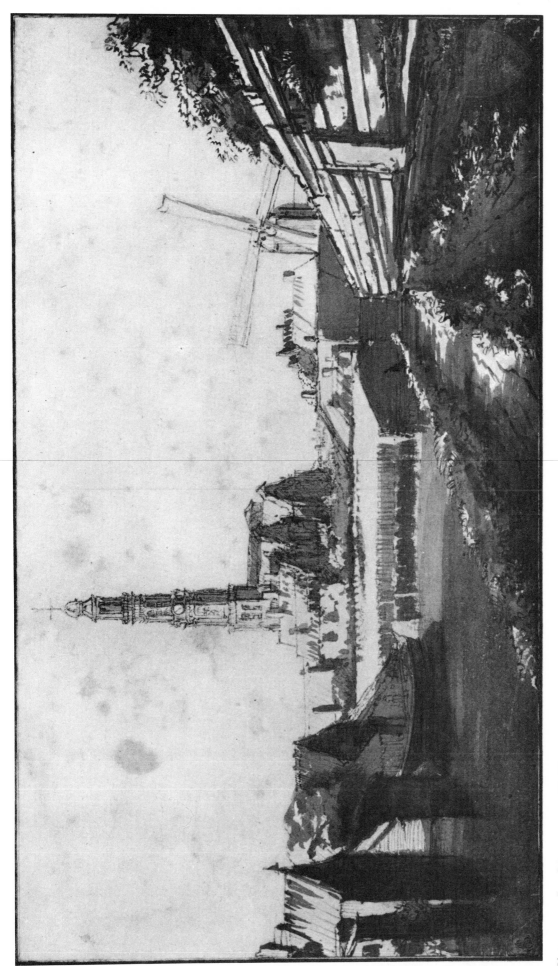

Plate 113. *Jan Vermeer van Delft*

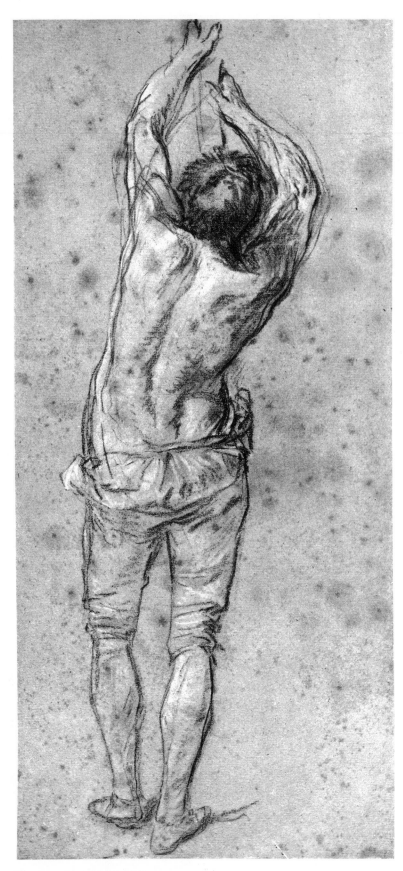

Plate 114. *Antoine Watteau*

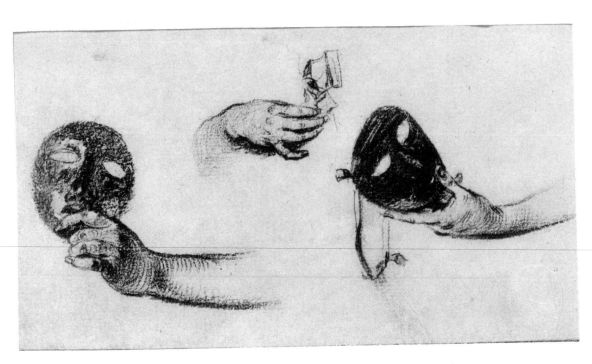

Plate 115. *Watteau*

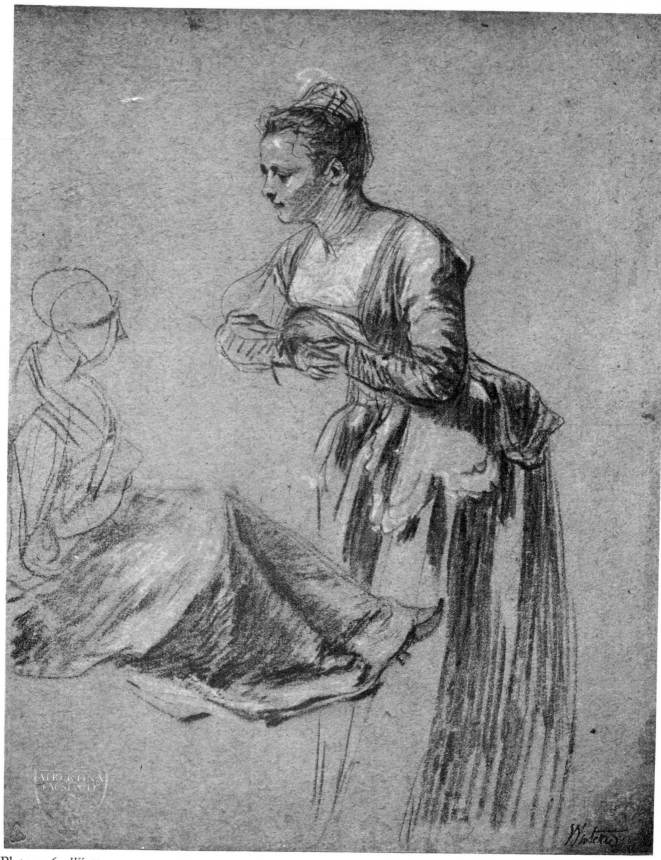

Plate 116. *Watteau*

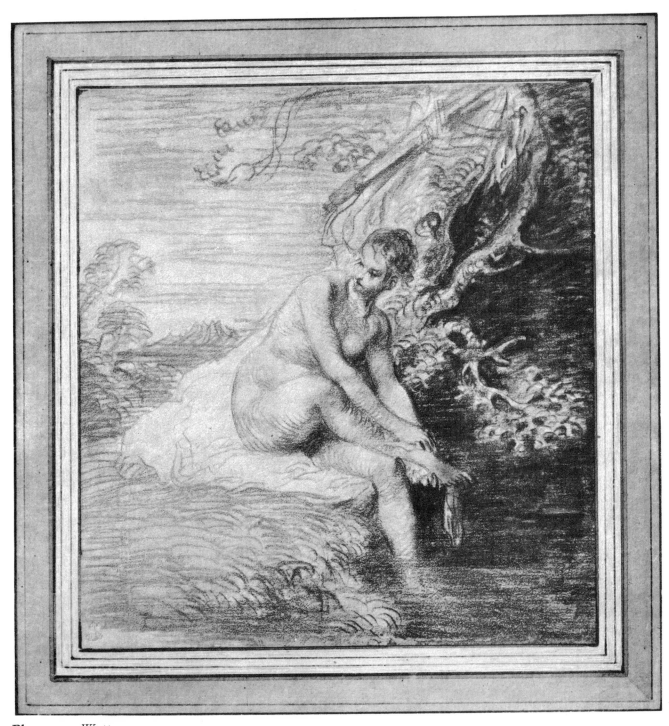

Plate 117. *Watteau*

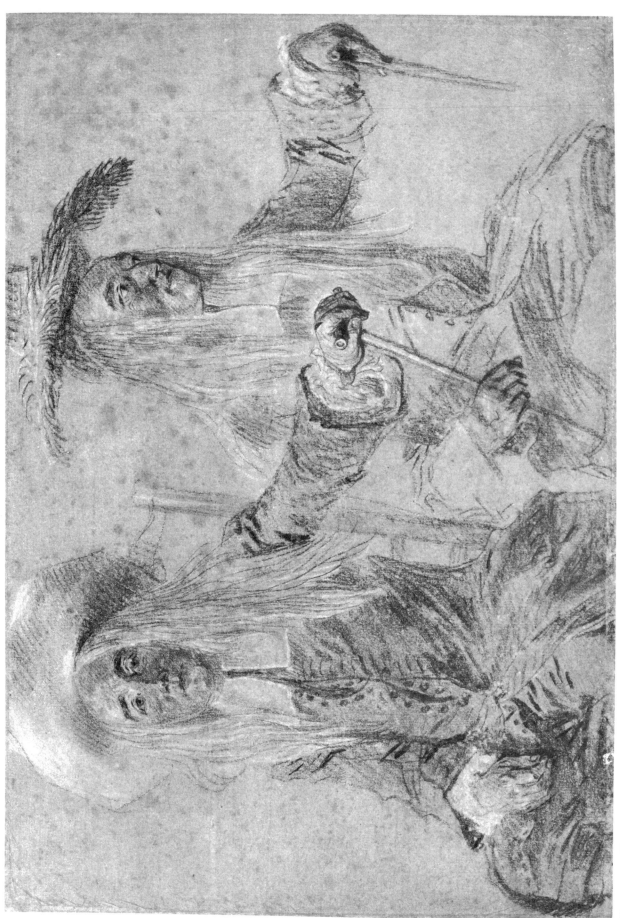

Plate 118. *Watteau*

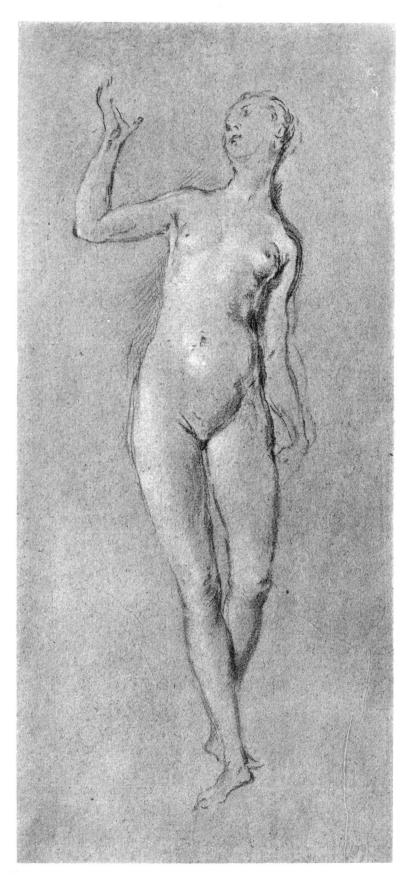

Plate 119. *Antoine Pesne*

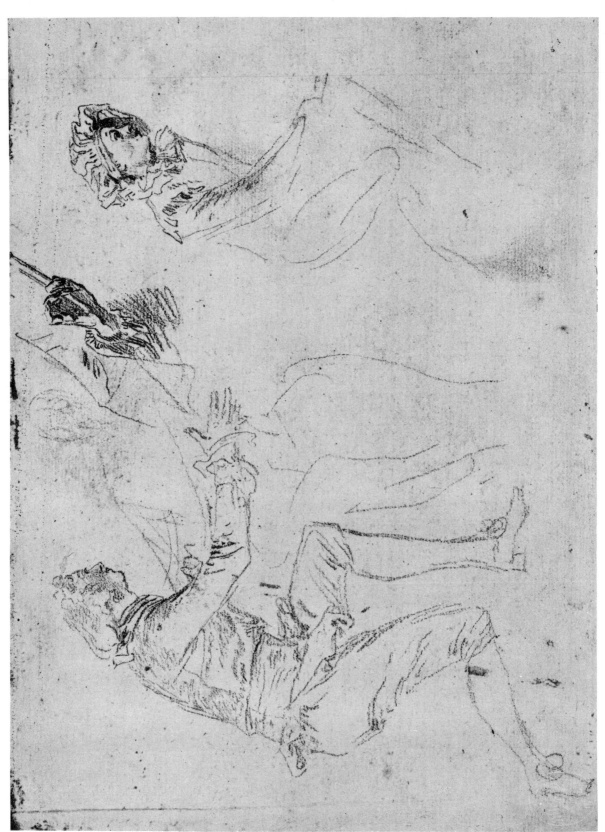

Plate 120. *Nicolas Lancret*

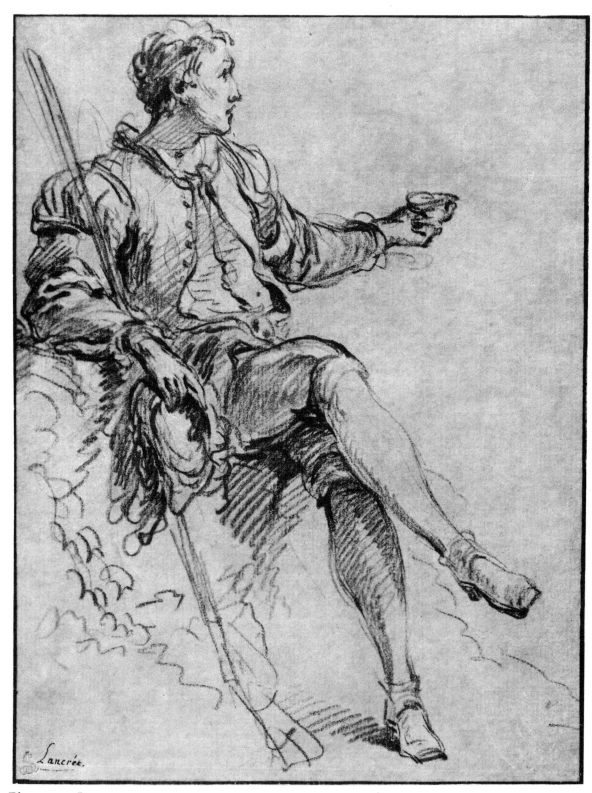

Plate 121. *Lancret*

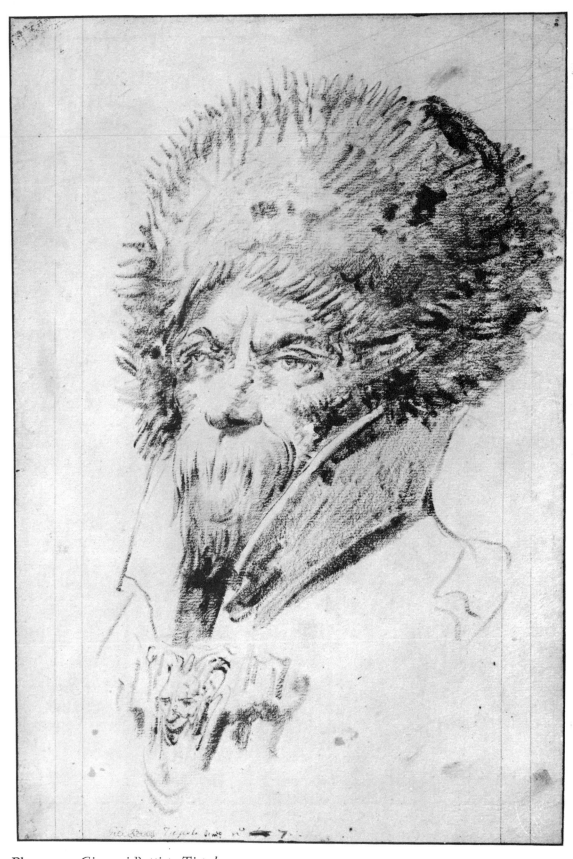

Plate 122. *Giovanni Battista Tiepolo*

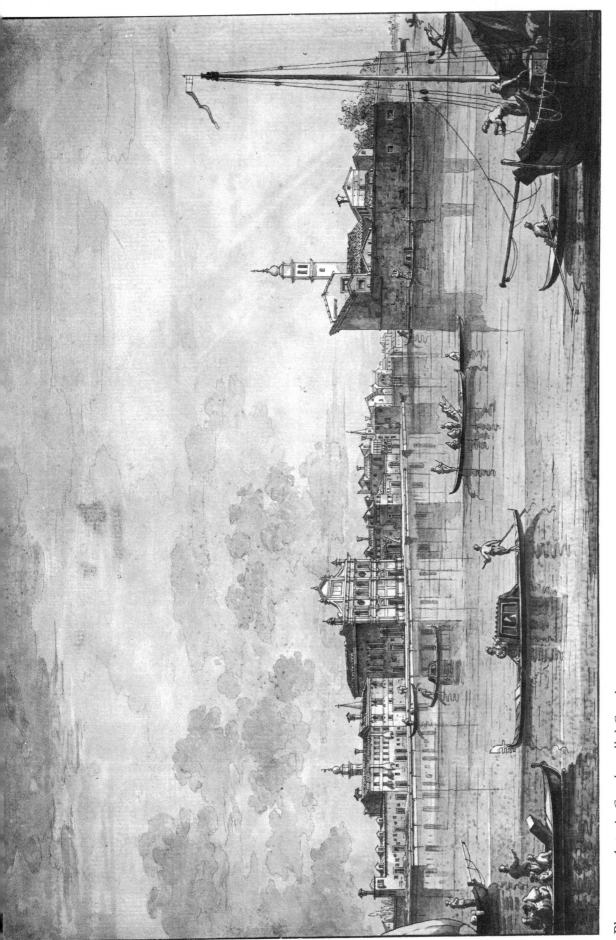

Plate 123. *Antonio Canale, called Canaletto*

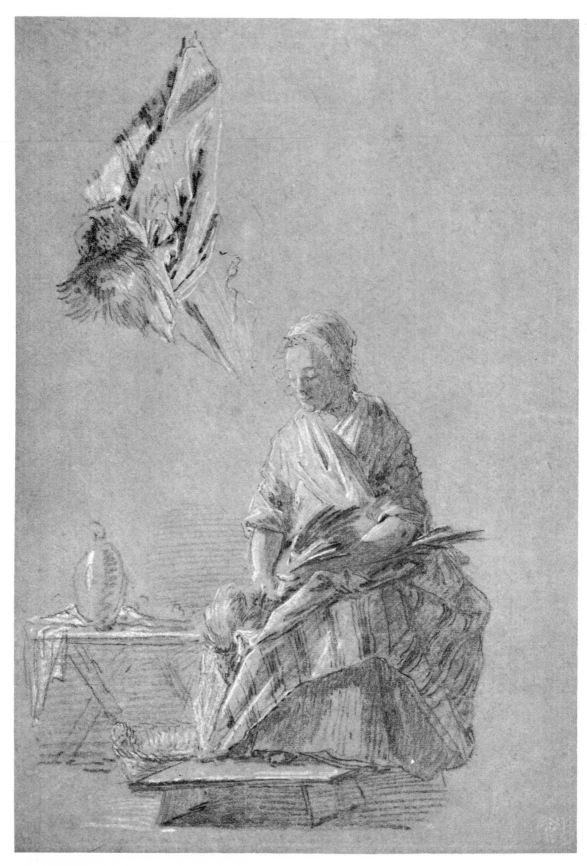

Plate 124. *Jean-Baptiste Siméon Chardin*

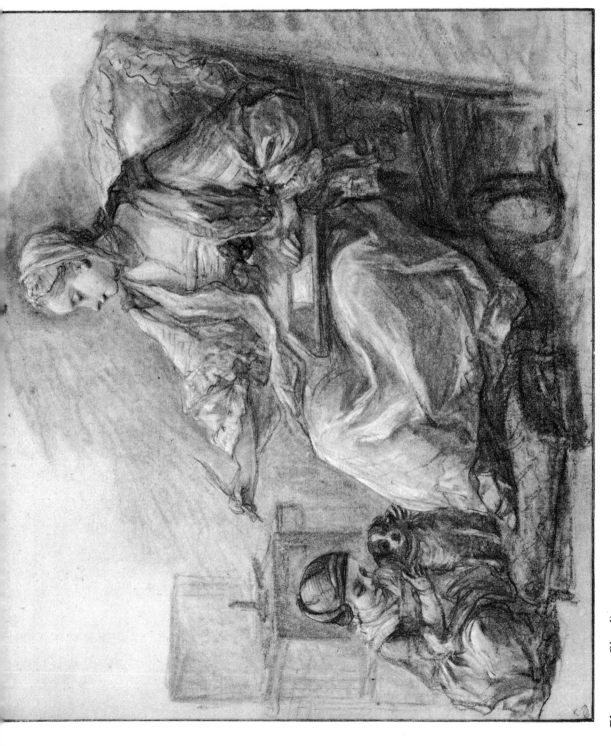

Plate 125. *Chardin*

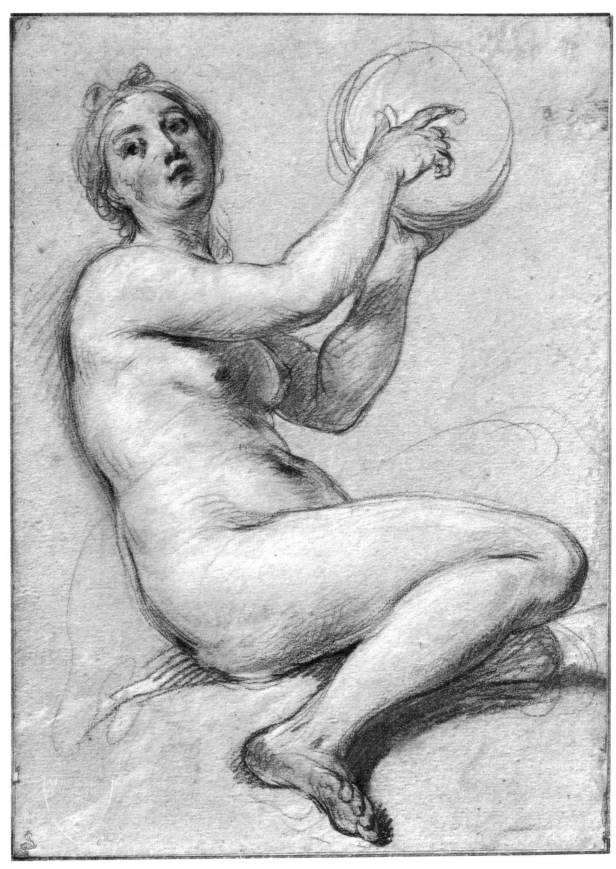

Plate 126. *Charles-Joseph Natoire*

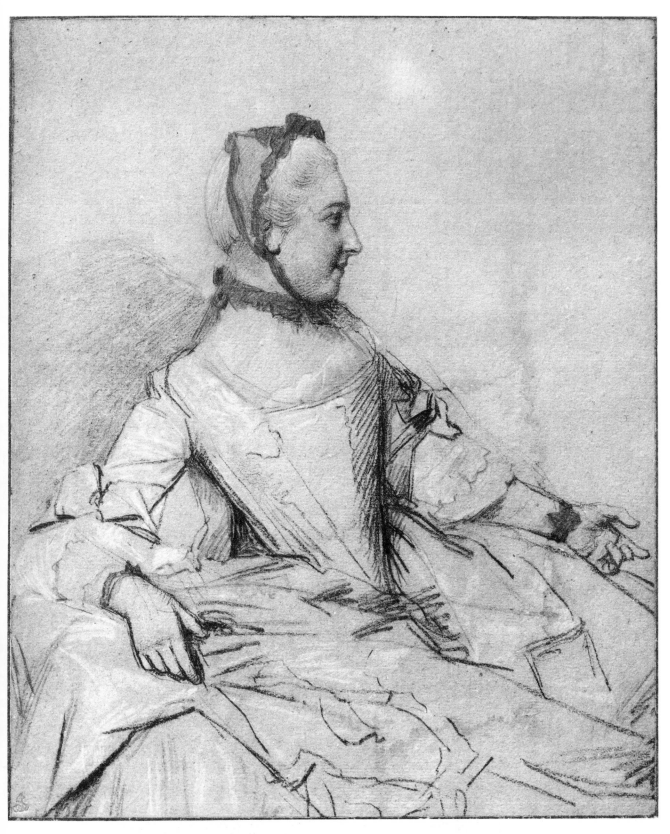

Plate 127. *Jean Etienne Liotard*

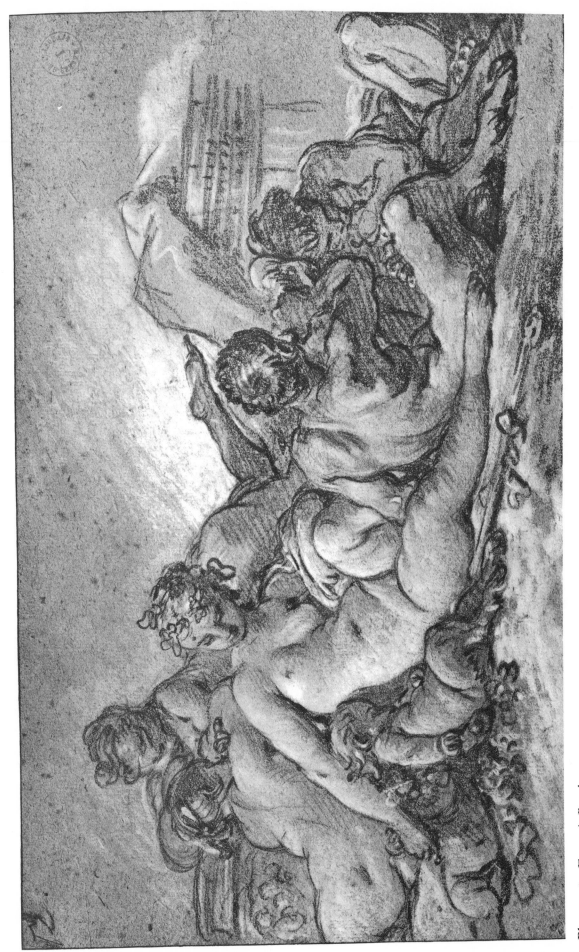

Plate 128. *François Boucher*

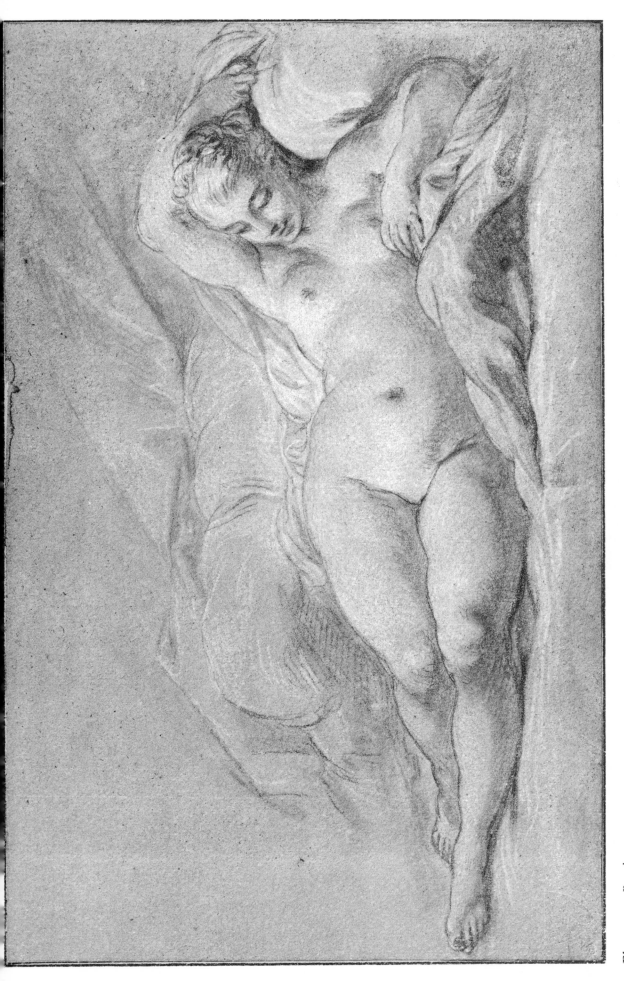

Plate 129. *Boucher*

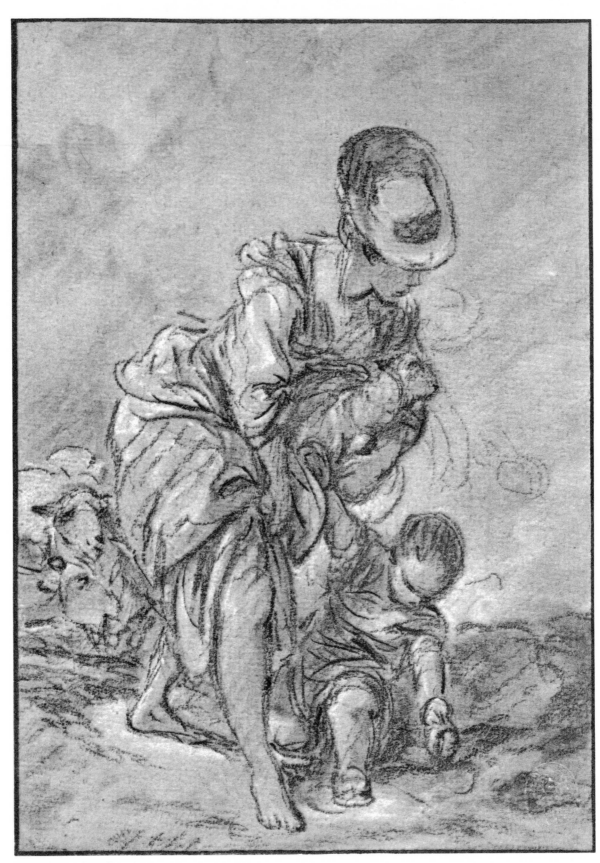

Plate 130. *Boucher*

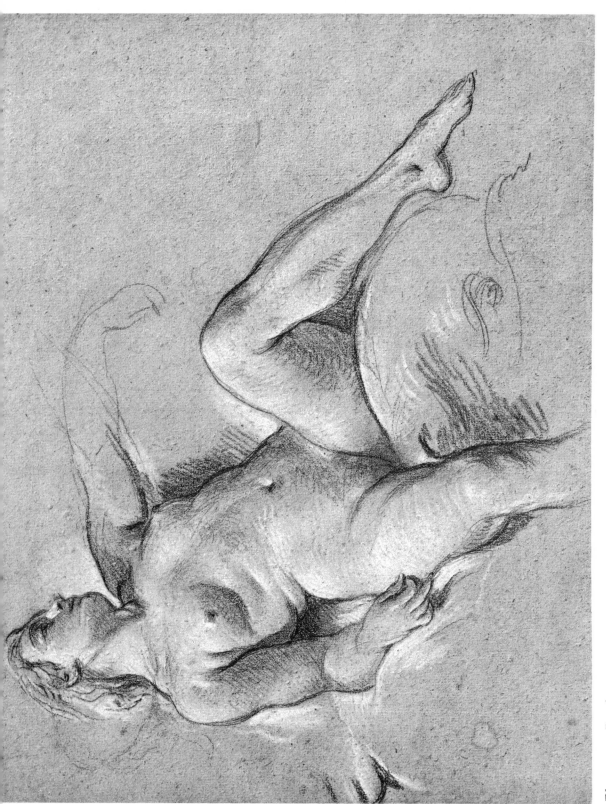

Plate 131. *Boucher*

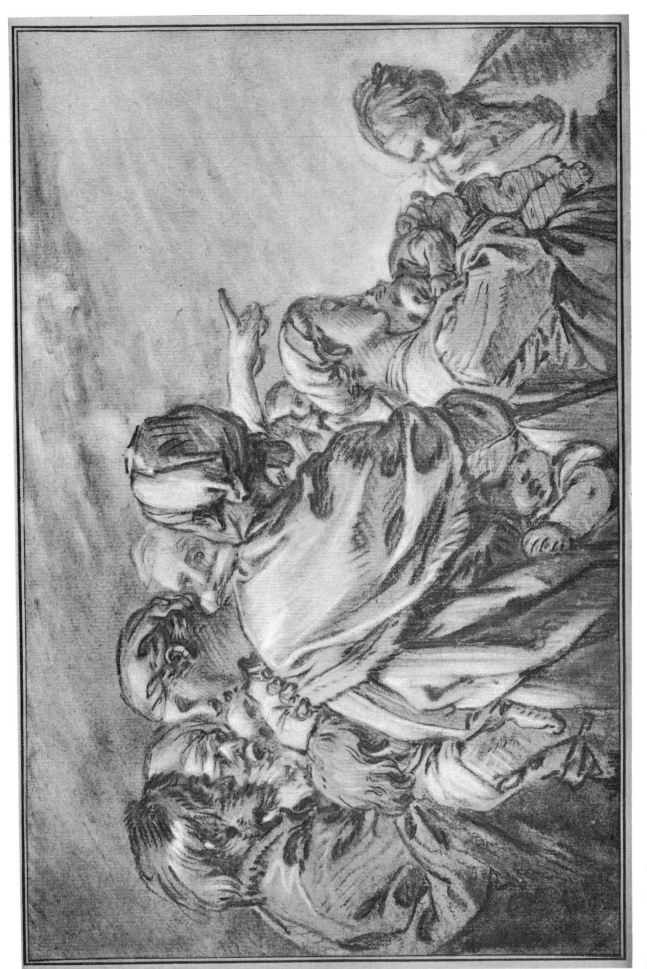

Plate 132. *Boucher*

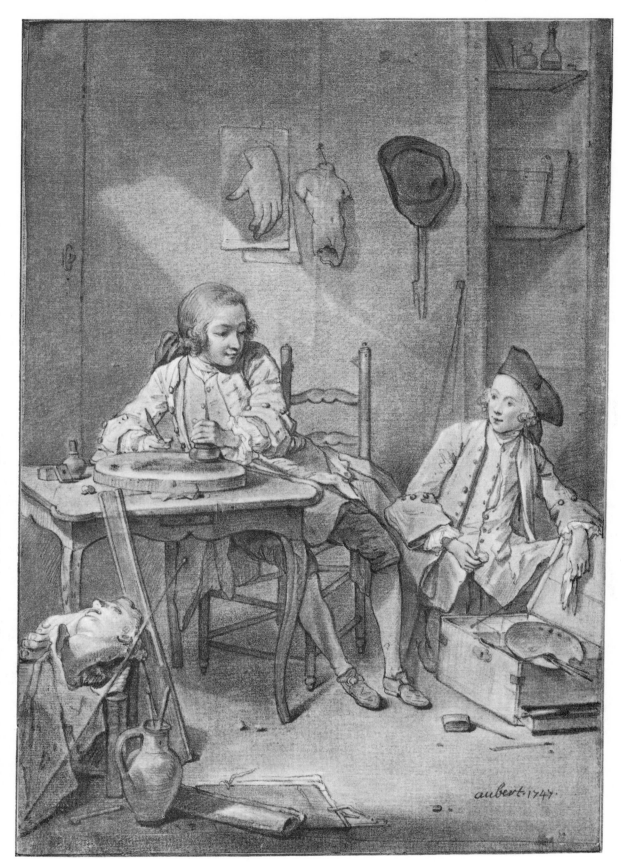

Plate 133. *Louis Aubert*

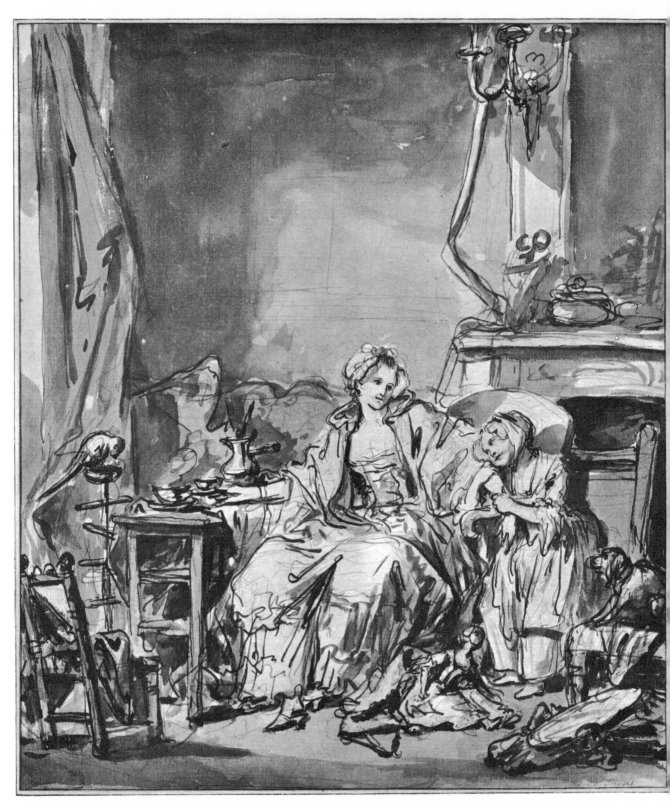

Plate 134. *Jean Baptiste Greuze*

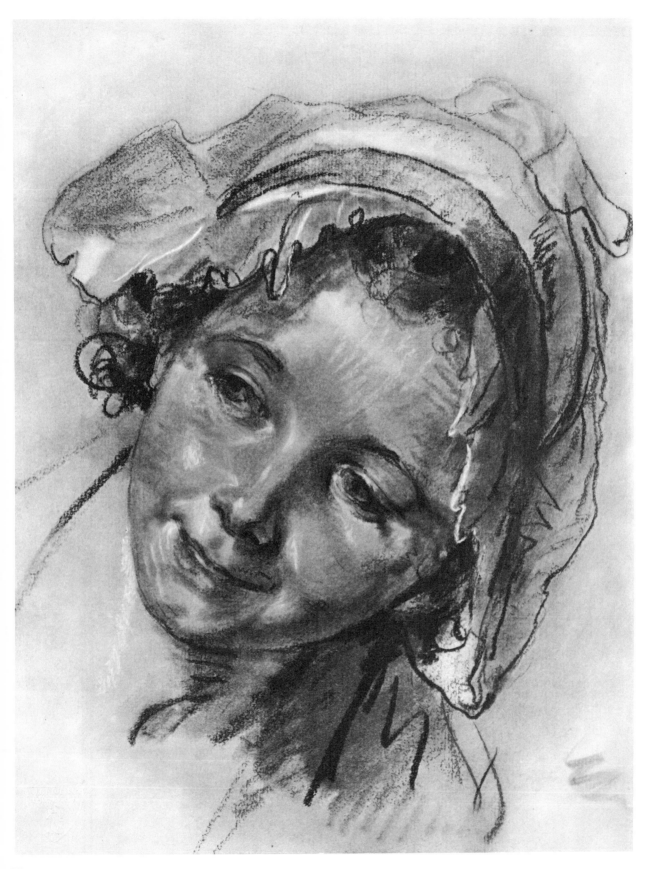

Plate 135. *Greuze*

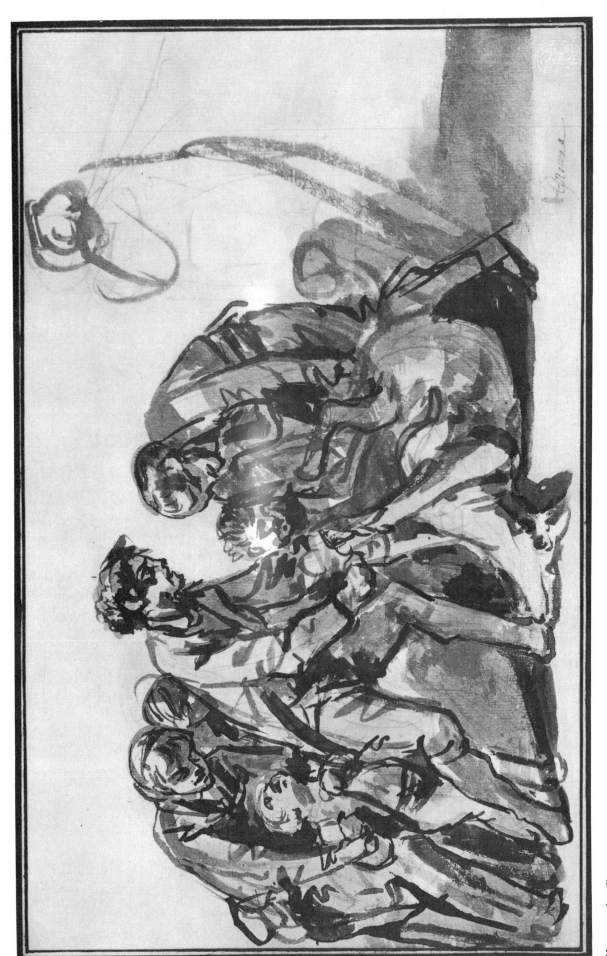

Plate 136. *Greuze*

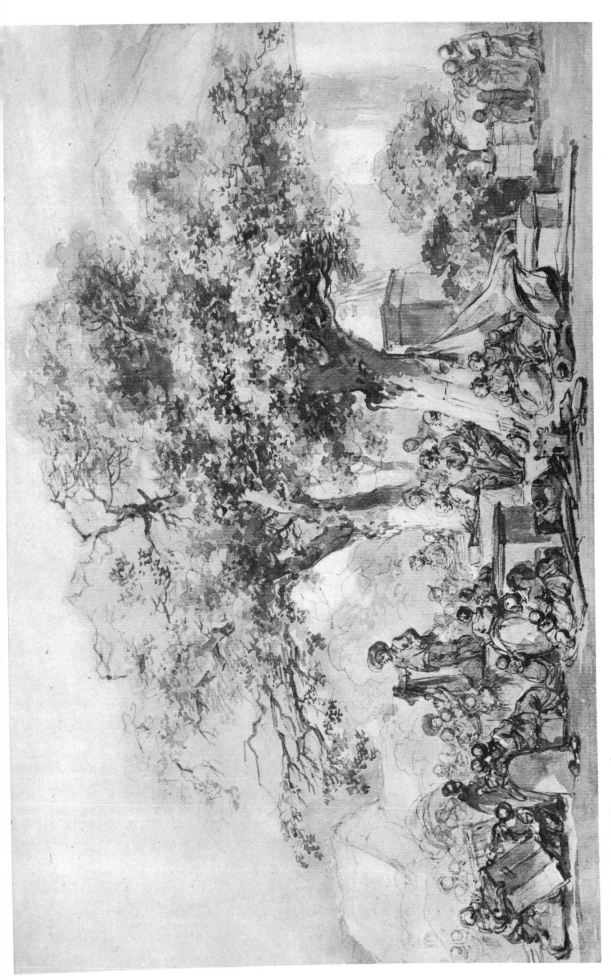

Plate 137. *Jean Honoré Fragonard*

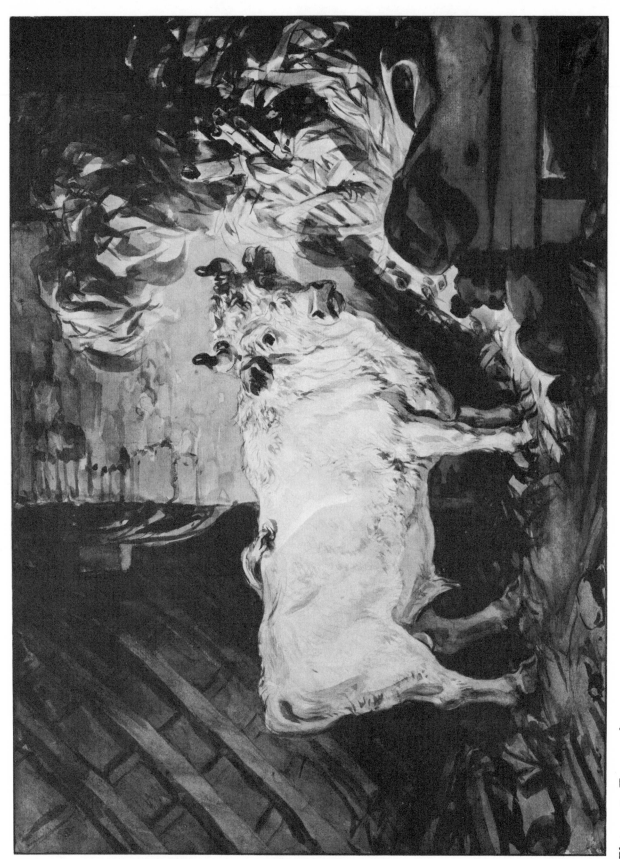

Plate 138. *Fragonard*

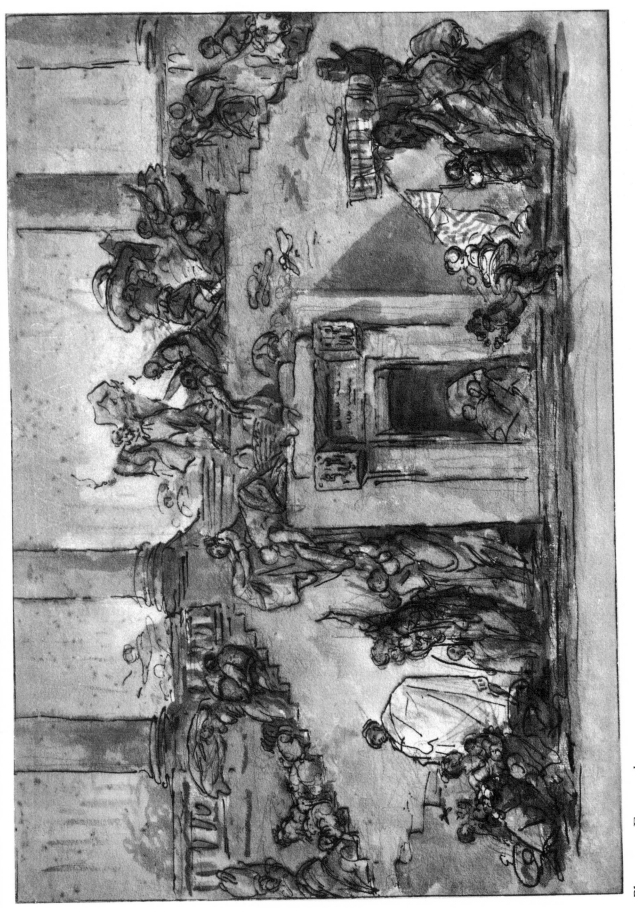

Plate 139. *Fragonard*

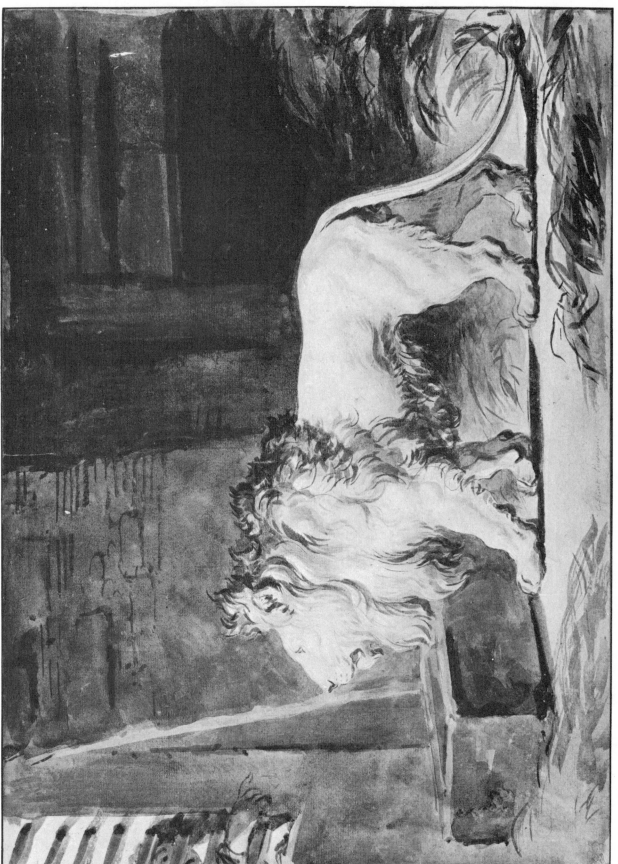

Plate 140. *Fragonard*

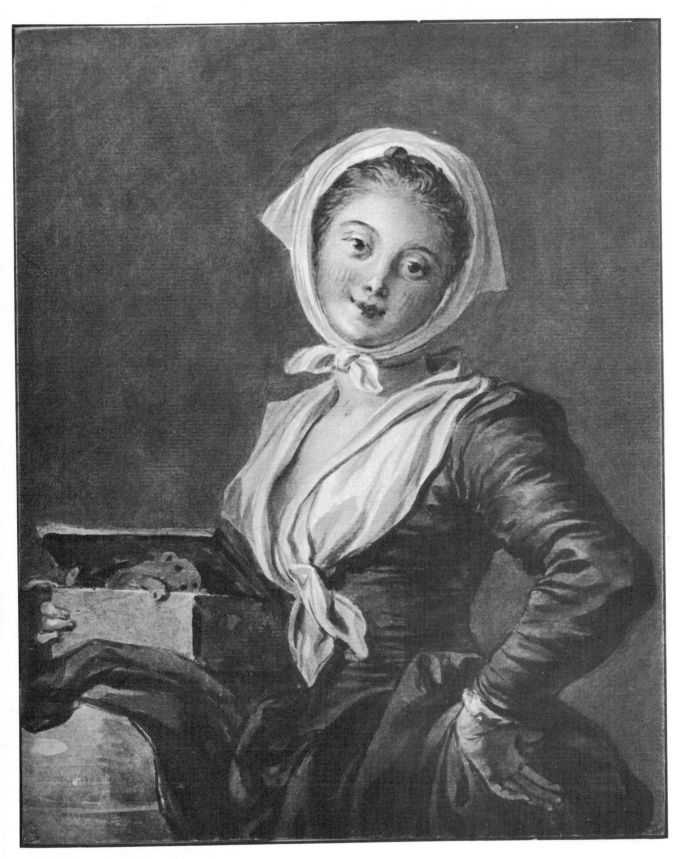

Plate 141. *Fragonard*

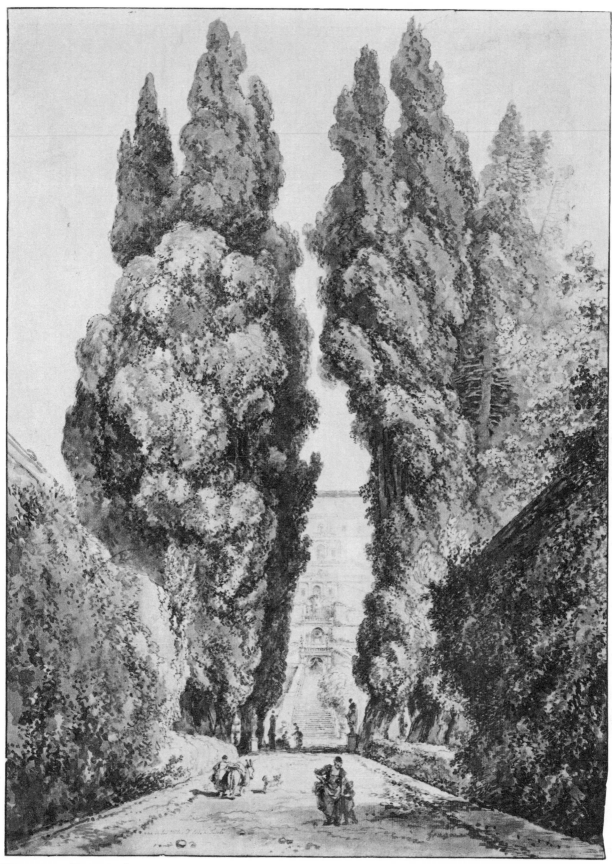

Plate 142. *Fragonard*

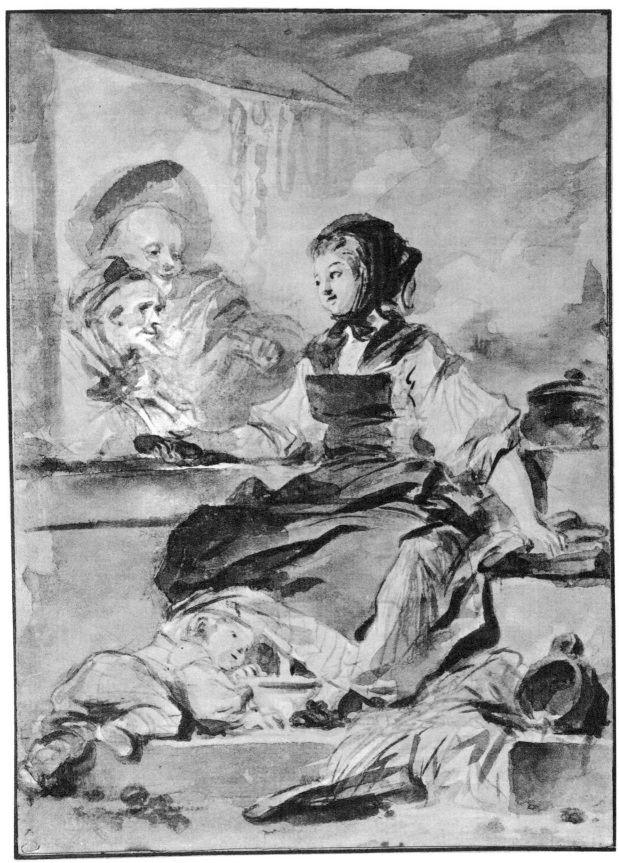

Plate 143. *Fragonard*

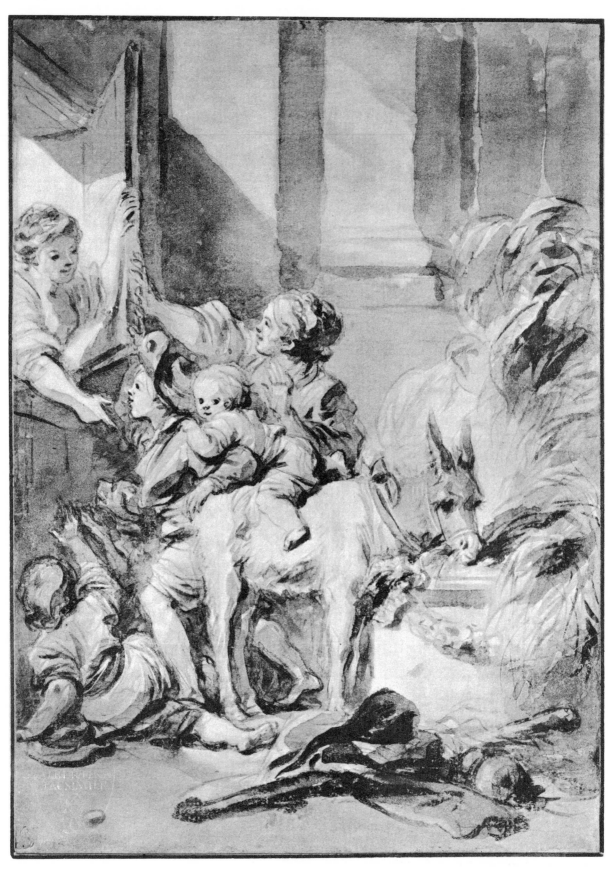

Plate 144. *Fragonard*

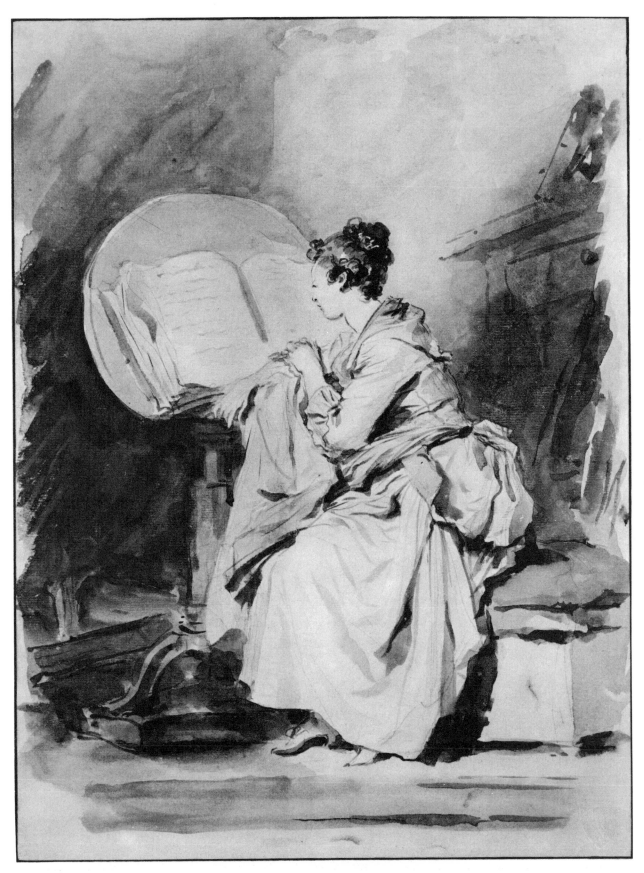

Plate 145. *Fragonard*

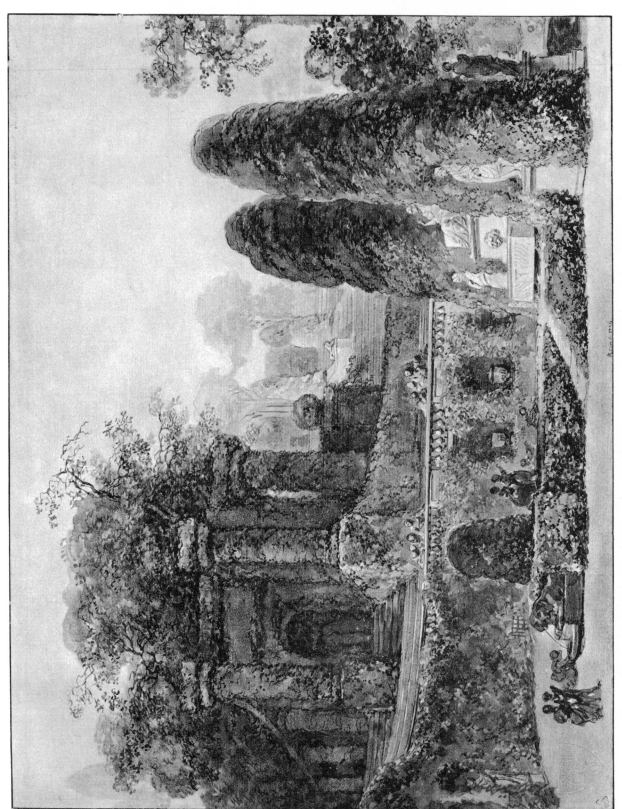

Plate 146. *Fragonard*

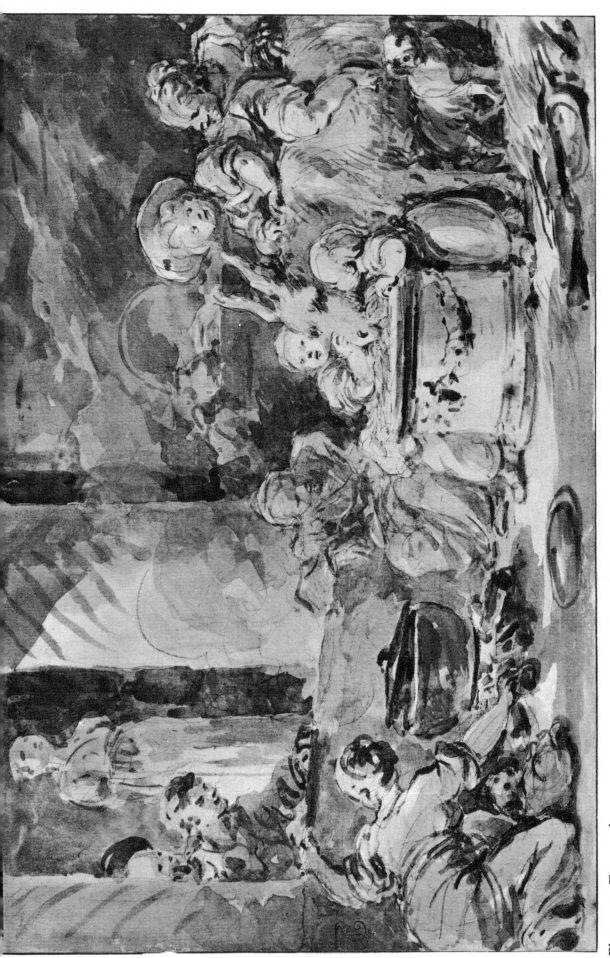

Plate 147. *Fragonard*

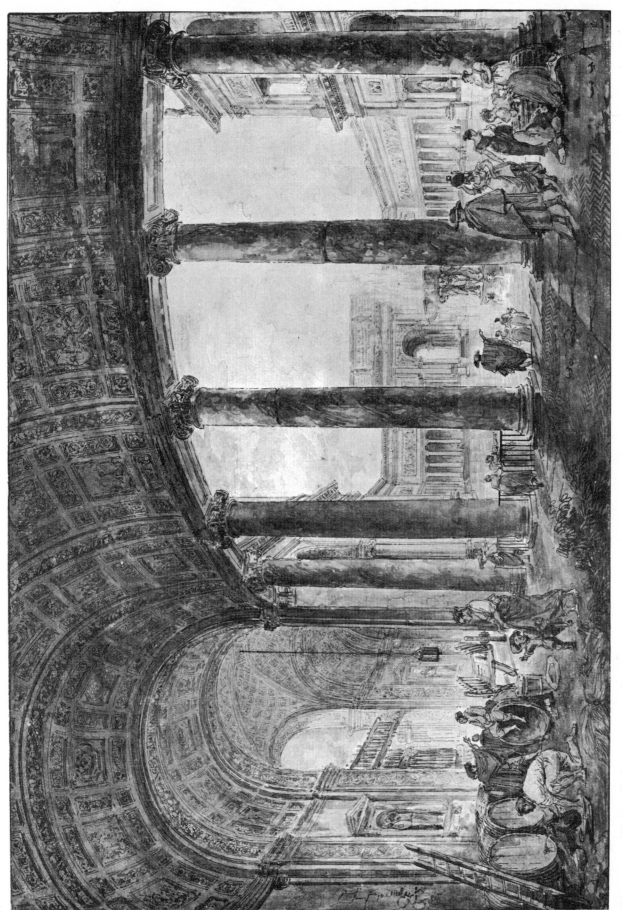

Plate 148. *Hubert Robert*

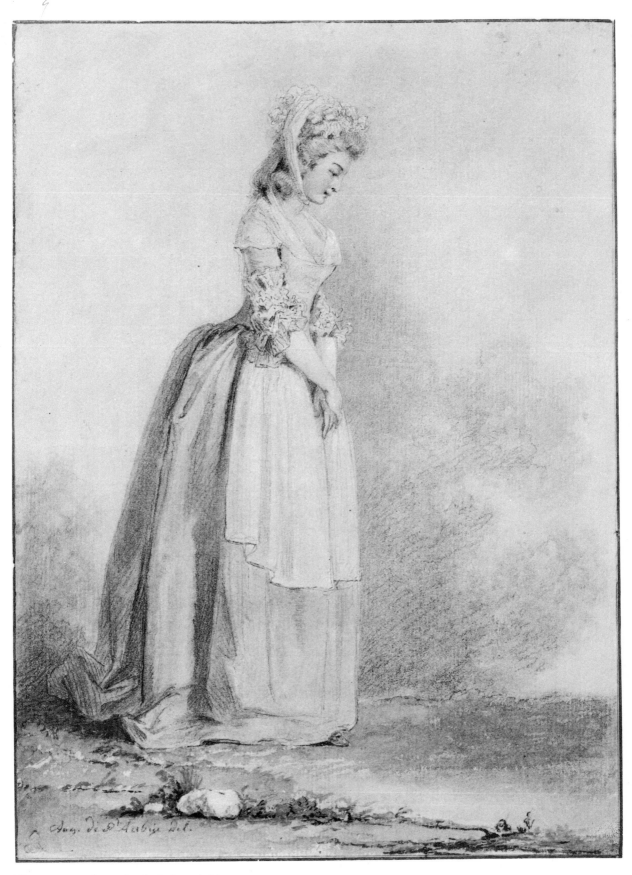

Plate 149. *Augustin de Saint-Aubin*

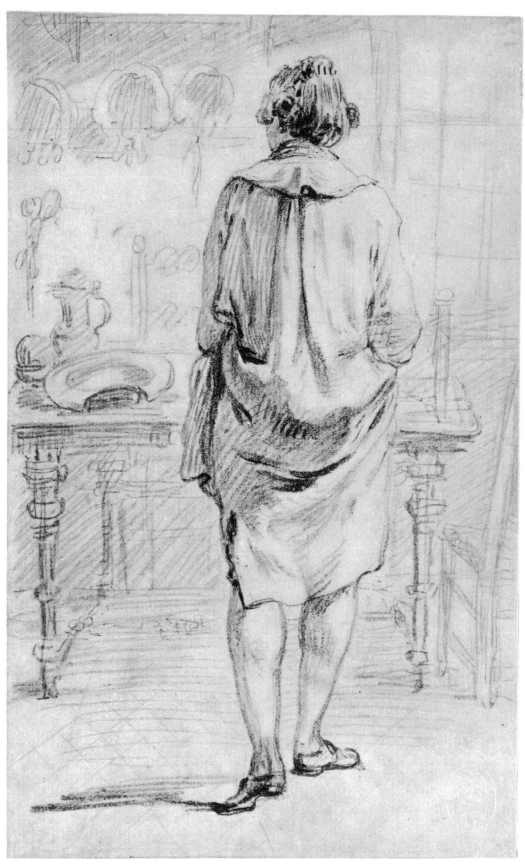

Plate 150. *Saint-Aubin*